Family Photography

The Digital Photographer's Guide
to Building a Business on Relationships

Christie Mumm

AMHERST MEDIA, INC. ■ BUFFALO, NY

Published by:
Amherst Media, Inc.
P.O. Box 586
Buffalo, N.Y. 14226
Fax: 716-874-4508
www.AmherstMedia.com

Publisher: Craig Alesse
Senior Editor/Production Manager: Michelle Perkins
Assistant Editor: Barbara A. Lynch-Johnt
Editorial Assistance from: Chris Gallant, Sally Jarzab, John S. Loder

ISBN-13: 978-1-60895-302-8
Library of Congress Control Number: 2010940509
Printed in Korea.
10 9 8 7 6 5 4 3 2 1

Check out Amherst Media's blogs at: http://portrait-photographer.blogspot.com/
http://weddingphotographer-amherstmedia.blogspot.com/

Table of Contents

PART TWO

To Everything There Is a Season

PROLOGUE
Why We Are Not Talking (Much) About Weddings

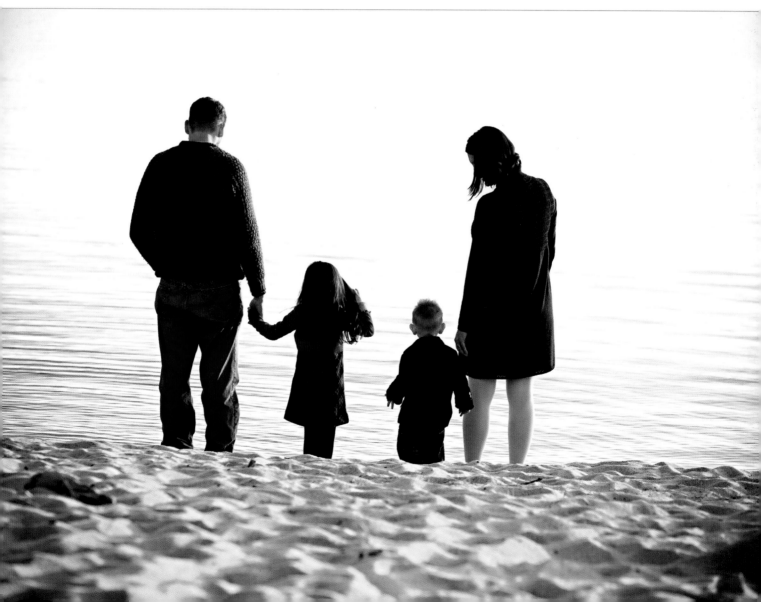

About the Author

Christie Mumm is the owner of JLM Creative Photography in Reno, NV. Christie began her journey with photography in her early teens and was encouraged to pursue her passions by her very supportive family and friends. Since opening her business in 2001, she has experienced exponential growth from year to year by working closely with families to capture lasting memories through lifestyle photography. Christie maintains a business philosophy that is focused on her clients and their families, and truly loves the wonderful people she is blessed to work with. In the summer of 2009, Christie realized a long-time dream when she was able to open a small boutique studio in downtown Reno, making the step from a home-based photographer to a studio-based one. Christie firmly believes in running her business debt-free and feels that this has allowed her to continue to experience growth even during national economic downturns. She has been married to her best friend for ten years and is the mother of one precocious and creative young daughter. Christie has a deep love for her work and is delighted to be able to share her experience and knowledge with other photographers.

Dedication

This book is dedicated first and foremost to God, whose guidance, gifts, and blessings have allowed me to pursue my passions into a career that fulfills my soul in so many ways. There are not enough words to describe my gratefulness to Him.

Secondly, I dedicate this book to my family. To my husband Jeromy, whose unfaltering faith in me has been my rock and shelter for more than a decade: I could not have done this without you, honey. To my beautiful daughter, my muse, my mini-me, and my purpose for being born: I adore you, my precious angel. To my mother, whose loving support and nurturing made me the woman I am and gave me wings to fly. To my father, whose confidence in my abilities and investment in my life have meant more to me than I know how to say. To my sister Noelle, whose enthusiasm and eagerness to join me on this journey gives me hope, and for her ability to make me laugh even when I want to cry. To Dave, for your constant encouragement and love.

I would also like to dedicate this book to my dearest friends in the world, Deb, Kim, Lynne, and Allison, who helped me to grow this business and who have rejoiced with me at every turn. You four are my angels and I love you!

And last but not least, to all my clients-turned-friends: without your confidence and beautiful faces, I would not have a business to write about. You are all so dear to me!

Foreword

When my oldest daughter Christie asked me to write the foreword to this book, I felt honored to say the least. What could be more exciting than watching your children follow their hearts and discover their passions and talents? The honor I feel goes much deeper than simply pride and excitement for her accomplishments. The simple definition of honor is "to respect." As I reflect on the path Christie is following, I can't help but feel deep respect for her.

The premise of this book is building a business based upon relationships. Of course, most successful business ventures are focused on the clients they serve. This sounds so simplistic. It is about meeting the needs of the clients and building relationships that keep your clients coming back. This book goes much further than simply the retention of clients; it strives to impact the relationships that portrait clients have with their own families, extended families, friends, and acquaintances.

As a small child, Christie had a gaze that could penetrate the depths of one's soul. Little did I know that she was indeed studying eyes—and would one day pursue a career that mimics the eye in capturing through a lens what the eyes see every day. The wonder of memory has always been fascinating to me. We have the capacity to remember sights, scents, temperatures, sounds, feelings, and impressions among the vast array of cataloged images stored in our amazingly complicated brains. However, as I remember my own family members, at times it is difficult to recall with clarity the expressions, lines, and textures that are so distinct in the faces of those I love—and many that I dearly miss. I rely upon and deeply treasure the photographs that I have collected over the years.

Christie has an innate ability to capture through the lens those expressions and personality traits that make each of us so unique. As her clients view their portraits, I have witnessed time and time again a profound appreciation for her work. Her clients are able to deeply connect with their images, as she translates the feelings they are experiencing into treasured works of art that will last through many generations.

We certainly cannot overestimate the value of photographs. The value added is in the relationship that portrait clients have with their photographer. Christie has an amazing way of entering into the hearts and lives of her clients as she develops, grows, and maintains wonderful lifetime relationships through her work. It is apparent to all who meet her that she loves families and loves her work. Her enthusiasm and warmth are translated into a growing business that brings joy to those around her. As you read this book, I know you will see that there is a great deal of wisdom and expertise presented here.

With deep respect and love,
Ginnie Fox

Family Is the Cornerstone of Our Society

Everyone on this planet shares one simple truth: we all have a family. Whether we know them (and like them) or not, whether we are close-knit or estranged, we all have a mother and a father: a family. In our modern world, the family has definitely taken on many new forms. We have blended families, adoptive families, "like family," and more. But even with the changing times, one thing has not changed: everyone needs family. Human beings are social creatures; we are built to live in community and to make strong emotional connections to other human beings.

I love the family. I adore the unique and beautiful bond between siblings, that delicate mix of affection and rivalry to which nothing compares. I love the way wives and husbands transform into mothers and fathers, the way two people in love become something different to each other when they become parents. I love the bond between parent and child, the child's loving and trusting gaze, the parent's adoration and protective, gentle guidance. There is no other person in a child's life who holds this special position. Even after being disciplined for some bad behavior, I remember my little girl, with tears streaming down her face, diving into Mommy's arms for the comfort and acceptance she knew would always be there—despite her misdeed. The relationship between parent and child is so beautiful, so special, and such an organic, dependable source of real emotion.

I love capturing the bond between parents and their children.

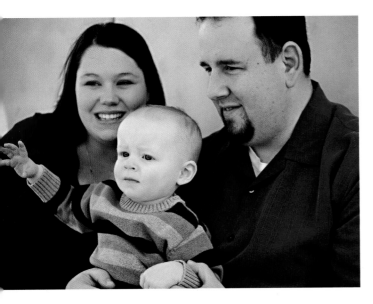
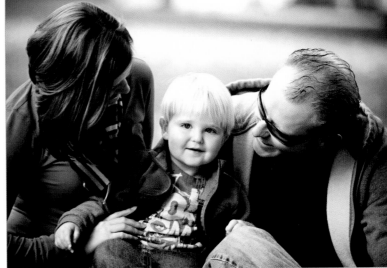

Children learn how to behave, how to relate, and ultimately how to live, by the example their parents set. If parents place a high premium on preserving memories, on documenting their children's lives, then the child will value those things as well. For this reason, I maintain that building a strong foundation with clients, on a personal level, is the most effective and dependable way to ensure years of success in your business. The children who grew up in your studio will choose you to document their own families when the time comes—if you take the time to truly connect with them, to learn about them, and to show that you care.

I have built my business from the ground up and built it on relationships—not with credit cards or business loans to fund expensive marketing campaigns. I have invested my heart and soul into the lives of the people I work with. My devotion to them and their stories has been the catalyst for the growth of my business from a small, part-time venture run from my home

Building and maintaining a strong personal relationship with all of your clients is the best way to ensure the success of your business.

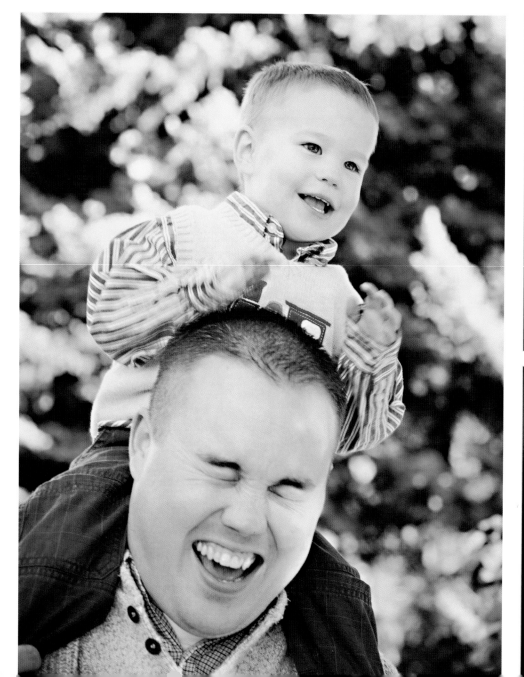

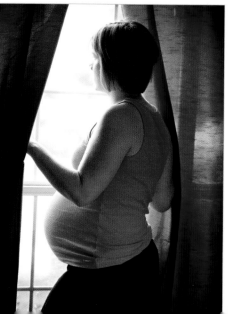

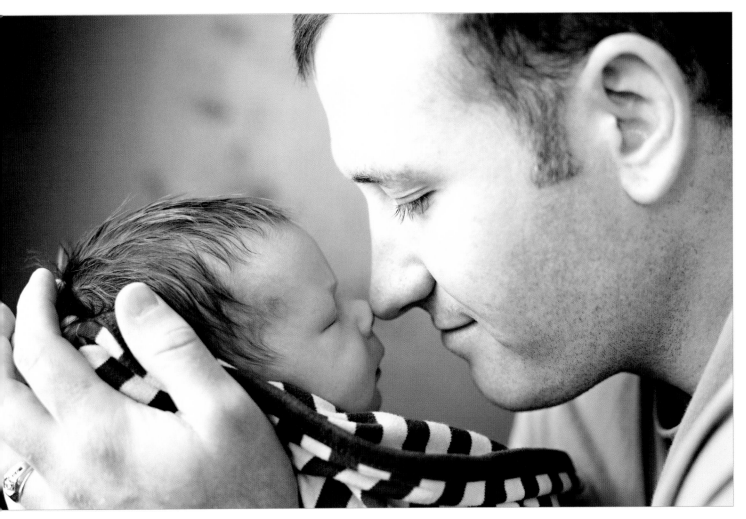

There are challenges in documenting every season of a family's maturation—but the ability to consistently produce beautiful portraits is a key factor in creating clients for life.

to a fast-growing and successful full-time business located in a downtown studio.

This book will cover the business of being a family photographer from my personal standpoint. I will discuss relationship marketing that is simple and effective (not to mention very affordable), the philosophy of building customer evangelists, and how to go about creating life-long customers. As you will learn, there are unique challenges and opportunities in photographing every season of a family's maturation—from maternity portraits to senior portraits and beyond.

During a recent open house at my studio, I was overjoyed to hear one of my long-time and very cherished clients practically repeat back to me my own business philosophy. As we said goodbye and hugged, she said "I can't wait to have a lifetime of pictures of Ali taken by you. You will be photographing her wedding in another twenty years!" I was so elated! She got it—she understood what I strive to convey to my clients! She knows that I am here for her family for the long haul. After half a dozen sessions with me, she is confident that she can count on me to consistently create beautiful portraits of her family. More importantly, she knows that I care about her family. We have built a friendship that is stronger than any typical business relationship!

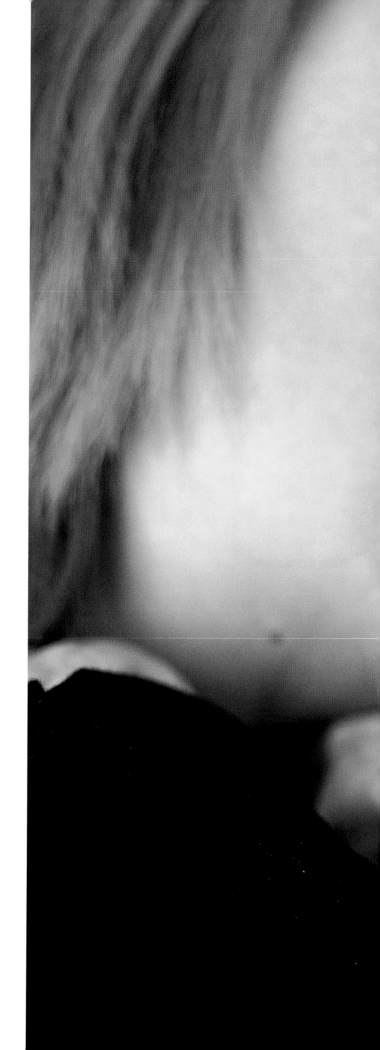

The Foundations of a Portrait Business

Before you can begin marketing yourself as a portrait photographer, you need to be sure you have the technical knowledge and equipment necessary to run a business. There is so much more to running a photography business than pointing a camera set on "P" ("P" is for "pretty picture," right?) at a cute kid and hitting the shutter button. Every professional photographer needs to have an intimate knowledge of the operation of their equipment and be comfortable shooting in almost any situation—and doing so in manual mode.

The following chapters will cover the basics of starting and running a portrait business. In addition to what I discuss here, you will want to check with your local government to make sure you have all the proper permits and licenses to operate a business in your city, county, and state. I cannot stress how important it is to run your business legally; before you take a single paying job, you need to be licensed in accordance with your local government's laws.

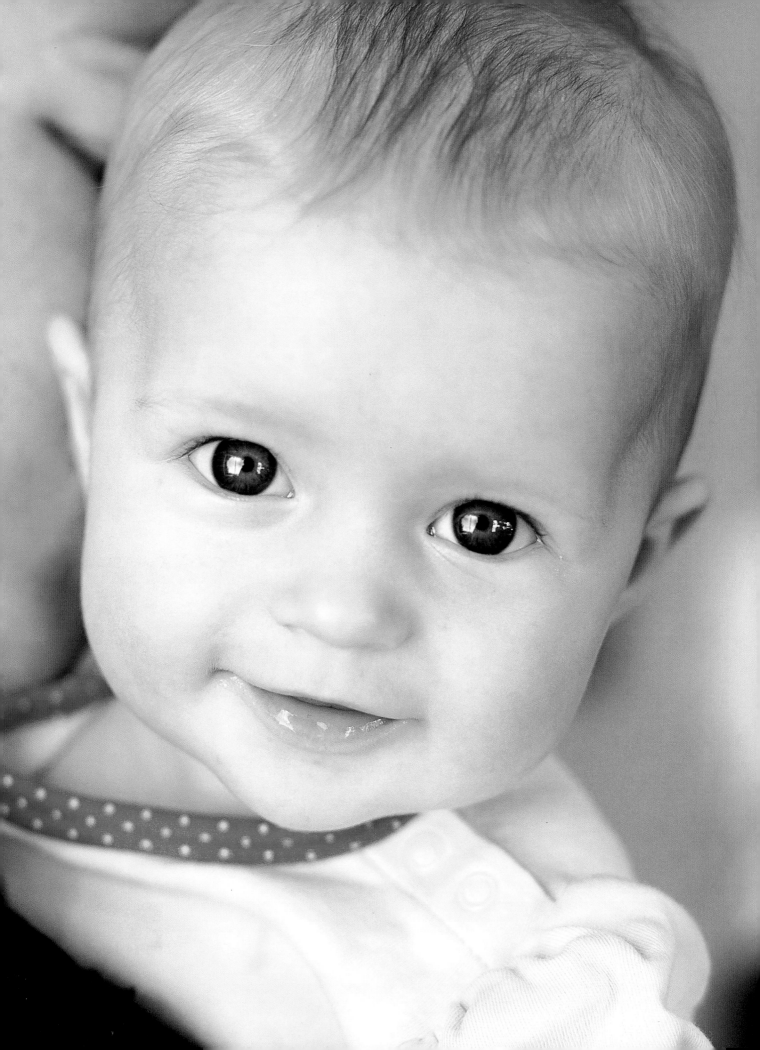

1. Tools of the Trade

Film *vs.* Digital

With the advent of extremely advanced digital cameras and equally powerful editing software, our industry was revolutionized. The cost of camera equipment, film, and processing once made it cost-prohibitive for just anyone to pick up a camera and open their doors for business—but with digital cameras, everyone is an amateur photographer. I recently shot a wedding at which there were three guests, in addition to myself and my assistant, standing in the back and walking around with DSLRs (digital single lens reflex cameras). The relative ease of use of some of the entry-level DSLR systems has also made it very easy for enthusiasts to produce relatively good images and market themselves as professionals.

I opened my doors for business in 2001, at the tail end of the film era and the cusp of the digital. It took me another four years to make the jump to digital photography—and even then I still carried a film camera for another couple of years. I was not what you might call an early adopter; I wanted to be sure that if I made the jump, I would be happy with the quality of images I was able to produce in comparison to my film cameras. In fact, up until 2005

I made the transition to digital when I was sure I would be happy with the quality of the images I was able to produce.

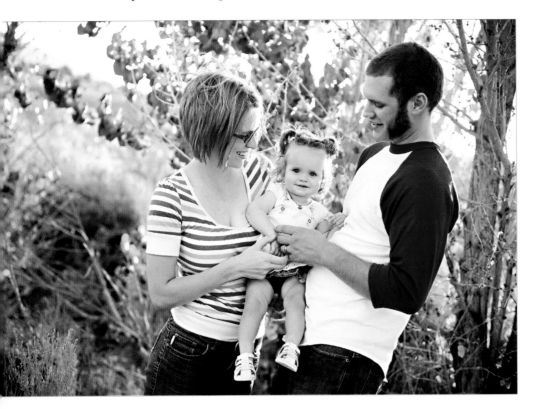

Whatever equipment you choose, it should suit your style and you should be comfortable using it. Your confidence in your equipment will put your subjects at ease.

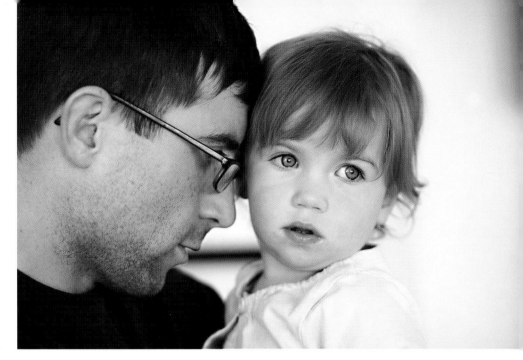

The affordability and ease of use of entry-level DSLRs has fueled the growth of the "Uncle Bob" photographer. Image by Keira Nolan.

I had a working darkroom in my home and processed and printed all of my own black & white images.

That being said, I have now chosen digital as my medium and am very happy with my choice. I do still, on rare occasions, pick up my old film cameras for fun, but all of my professional work is produced with digital cameras. I do not claim that digital is better than film. I believe that it should be a personal choice for every photographer, and I happen to admire many stellar film photographers who I suspect will never switch to digital.

The most important factor in the debate between film and digital really should be the photographer's style and comfort level. Whatever you choose as an artist, you need to know your medium thoroughly. The use of digital photography should not be a choice based on convenience or a lack of technical skill. Digital photographers should be able to shoot with their LCD screen covered, relying only on their expertise (rather than the little picture on the back of their camera) to determine proper exposure. Whatever you choose to use, your confidence in that decision will inspire confidence in your clients as well.

Camera Considerations

There are many great camera manufacturers in the industry today, so choosing a camera line can be quite a daunting task. When selecting a line of cameras to use for professional shooting, you need to consider the type of photography you will be doing. For example, in my experience Canon handles low light beautifully—with a minimum of digital noise. It has taken Nikon a while to catch up in this area, which, for me and my shooting style, is a must. On the other hand, Nikon has a reputation for very precise autofocus capabilities, with exponentially more focus points on their higher-level

models than their Canon counterparts. This is especially helpful when shooting moving subjects and when working at large apertures where precise focus is a must. Sony, Olympus, Pentax, and Minolta also have some very impressive DSLR models, which warrant a close look when comparing digital cameras (however, I must admit that my experience with these lines is fairly limited).

Prior to committing to any camera line, I recommend that you do some research. I have found that www.DPReview.com offers the most in-depth and reliable reviews of digital camera. I particularly enjoy their side-by-side comparison feature, which allows you to more easily evaluate different cameras. This can make the daunting task of camera shopping much easier.

Whichever line you choose, make a decision and stick with it. Incurring the cost of switching systems every couple of years is really unnecessary and can hinder the growth of your business—not to mention that there is a learning curve to contend with when switching to a whole new system. This brings me to my next point: while camera equipment is important, it is not *more* important than you, the photographer. When it really comes right down to it, a skilled and personable photographer can coax amazing images out of any model with any camera. A photographer who spends too much time and money on acquiring the next big thing is focused too much on the equipment and not enough on the act of image creation. As in the debate between film and digital, it is more important to become a skilled and proficient operator of your equipment than to have the newest and most advanced gear.

To operate a portrait business you will need to own at least two professional-quality camera bodies. It is very irresponsible to head out to a portrait session without a backup camera. Equipment will inevitably fail at some point. Showing up to a shoot with only one camera body puts the photographer in a position to possibly miss the important shots and disappoint their client. This does not build confidence or strengthen your connection with the client.

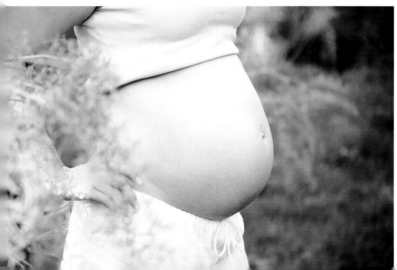

A skilled and personable photographer can coax great poses and expressions out of their subject with any equipment—so don't spend too much time worrying about choosing the "right" gear.

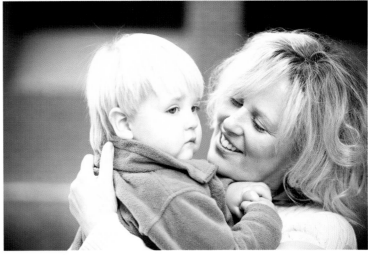

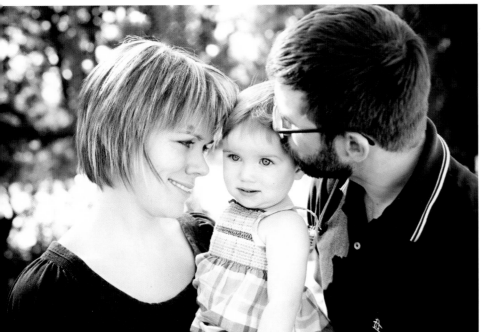

ABOVE (LEFT AND RIGHT)—You'll need lenses that allow you to create wider shots as well as more intimate close-up images.

LEFT—The points of light in the background of an image shot with a wide-open aperture are rendered as soft, round orbs. This effect, referred to as *bokeh*, is a very important part of my personal photographic style.

Lenses for Family Photography

The lenses each photographer prefers to shoot with are largely a matter of personal preference and style; I will cover that in the next section. High-quality lenses, however, are a must. Placing a second-rate lens on a high-end imaging device is silly. It prevents you from getting the very most out of your camera. You should have as many lenses as you feel you need to produce the type of images you are shooting for, but not so many that you are weighed down by carrying them all.

My personal style involves very blurred backgrounds and an extensive use of selective focus. I love the look of a smooth, soft background or the soft orbs of *bokeh* ("blur" in Japanese) created by small points of light be-

hind my subjects. Because my style is largely dependent on the use of wide-open apertures—you will rarely find me shooting at an aperture higher than f/3.5 or f/4.0— I choose to shoot with mostly prime (fixed focal length) lenses because they offer larger maximum apertures. This also allows me to use the beautiful natural light in more situations. Other photographers prefer to shoot with zoom lenses that cover most of the wide-to-telephoto focal lengths, allowing them to carry fewer lenses. This is all really a style choice, so I do not endorse one choice over the other.

My favorite lenses are my 85mm f/1.8 and my 50mm f/1.4. I also carry a 100mm f/2.8 macro lens, and a 28mm f/2.8 wide-angle lens. When I am trying to be

Prime lenses allow you to shoot in situations with lower light because they offer larger maximum aperture values.

a little more stealthy, as when photographing shy kiddos, I frequently use my 70–200mm f/2.8L (my only zoom). For general shooting, a 50mm lens (28–35mm for cropped sensors) is very useful; every photographer should have one in his or her kit.

Computers and Storage

Whether you have chosen digital or film as your medium, you will need a computer system for your business. There is, again, another big debate about which of the two major operating systems to use: Mac or PC. Again, it's really up to the photographer. If you are comfortable with one or the other, then stick with that.

If you are shooting with digital cameras, it is very important to have a computer system with enough RAM and processing power to handle large

When photographing

shy kiddos, I frequently use my

70–200mm f/2.8L (my only zoom).

image files. You will also need a large, calibrated monitor. Monitor calibration is an absolute must for all professional photographers because it ensures proper color reproduction from editing, to viewing, to printing. I personally use Datacolor products for monitor calibration. Their Spyder3 Pro is a wonderful device and offers the ability to calibrate CRT and LCD monitors as well as laptops and projectors. I also recommend investing in some type of graphic tablet for detailed editing work; Wacom products are the industry standard.

Another very important issue is file storage. Primary access and backups should be established—you can never have too much redundancy when it comes to photograph storage. I currently utilize a system involving large external hard drives, in volumes, connected to my network. These drives are the primary storage location for all photo files as well as all other business documents. I utilize a file database format in which every hard drive contains subfolders (*i.e.*, "Clients", "Business", etc.). Within the "Clients" folder, each client has a separate subfolder. In this subfolder are additional folders for each session date followed by a two-letter code for the type of session. For each client, the folder titled "Documents" holds all the client's information forms, orders, invoices, receipts, etc. The "Session" folder contains additional subfolders, such as "Originals" or "RAW", "Proofs", etc. A great way to

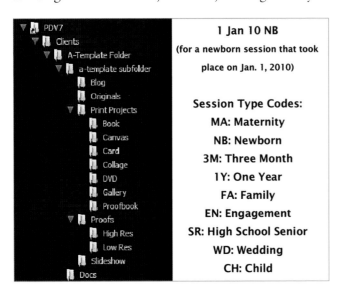

I utilize a file database format in which every hard drive contains sub-folders (i.e., "Clients", "Business", etc.).

save time when setting up client master folders is to keep a template file in the "Clients" folder. I call this folder "A-Template Folder" so that it shows up first in the alphabetical file listing. When I want to create a new client folder I simply copy and paste the template folder into the "Clients" folder, then rename it according to my naming procedures; it will instantly be set up with all the subfolders I need for the client.

For backup storage, I recommend a multiple redundancy system in which you back up your whole system periodically either online or onto an additional hard drive or tape backup system. You should also create another set of backups on optical media for each client; I burn two DVDs of the client's high-resolution JPG files after I process the RAW files. I store one copy in their hardcopy client file (in a filing cabinet in my studio); the other copy is added to a master folder of client DVDs that is kept at my home. I like the idea of having the files in two separate locations—just in case of fire, flood, or any other catastrophic situation.

Photo-Editing Software

Although some photographers have chosen to work with other programs, there are definitely industry standards when it comes to software. I will talk about those products exclusively. These are the products I have chosen to use—and I am very happy with them.

RAW File Processing. Because I choose to shoot RAW files and process them to JPGs, I need an application that can handle RAW files. For me, that program has always been Adobe Photoshop Lightroom. I have used Lightroom since its beta version (LR1); I've tried others, but I find it to be the best. I like the control it affords me—and because it was specifically designed for photographers, it is equipped with all the tools I need without being overloaded with things I do not need.

My RAW workflow is very simple and quick. First, I set up the client's master folder (usually before their session so it is ready to go). When I insert my memory cards into the reader, Lightroom opens automatically and shows me an import window. I navigate to the client's folder, select

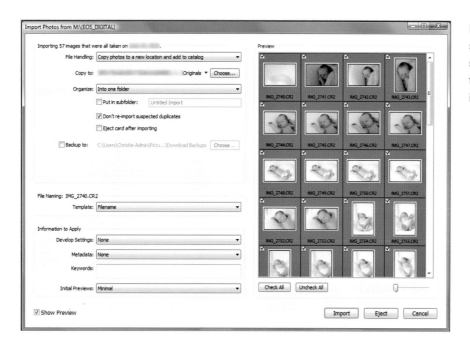

Images are imported into Lightroom and saved to the primary storage drive in the same action by selecting the "copy photos to a new location and add to catalog" option in the "File Handling" drop down menu.

After rating the images as either "picked" or "cut," the chosen images can be displayed together, hiding the rejected ones.

the "Originals" folder, and import the images by selecting the "copy photos to a new location and add to catalog" option. The next step is to cull out any images that are not acceptable—blurry, improperly exposed, etc. Lightroom has a fantastic feature that makes culling out rejected images really easy. I put one finger on the X key (to cut images) and one on the P key (to pick images) and quickly do a first cut through the files. Once the images are flagged in this way, I change the display filter to show only the picked images, hiding the rejected ones. From this point, I will cull out another 50 percent of the images, eliminating duplicate poses, etc. I find that clients value my opinion, so I only show what I believe to be the very best images from the session.

I then process the files by applying whatever settings I think they need—usually just a contrast bump, possibly a brightness bump, and white balance adjustment if needed. I try not to over-process the images at this point. What I want is an image that can be easily converted into a nice black & white or serve as the basis for any other creative technique I will later apply in Photoshop. I then export the JPG files in their full, high-resolution form and burn those files to duplicate DVDs.

Retouching. After processing the RAW files in Lightroom, I do not process my images much more. I will occasionally bring my favorites into Photoshop for additional fine-tuning if needed (or as requested by my client). I prefer not to over-process, because I really want my clients to have images in which they look like themselves. Just because you can do something in Photoshop does not mean that you should; I would hate to offend a client by retouching something out of an image that they do not want removed. Scars and birthmarks are a perfect example of things I don't touch unless I am asked to. Here's some good advice I once heard from another photographer: if it will be there in three weeks leave it; if it will be gone in three weeks (like a blemish or a scratch), feel free to retouch it.

Sharpening. At this point, the files are done except for resizing and sharpening. I leave all of the full-resolution files unsharpened until they are sized for their final use. For example, the proofs I will show at the proofing session are resized to the optimum resolution for my projection system then sharpened and saved in a separate folder. Print projects are sharpened when finished, as I find that album pages look best in print when the whole page is sharpened as one image. If I had previously sharpened all the individual images, I could end up with a page of unequally sharp images, which looks awful. In short, sharpening should always be the last step after resizing and editing.

I have found a couple of great sharpening actions that I love to use for different purposes. Kevin Kubota's Magic Sharp action is probably my favorite, followed closely by the Boutwell's Slice Like a Ninja action from the Totally Rad Actions 2 set. I find that Magic Sharp is great for larger images. I tend to like Slice Like a Ninja for sharpening images for web images and for proofing purposes. Experiment on your own; you may be able to come up with a sharpening process that you prefer.

Lighting

Light is our medium; the word "photography" literally means "to write with light." Therefore, there is nothing more important to a photographer than understanding how light moves, reflects, falls off, etc. I believe that photographers should be comfortable shooting with all types of light and equipped to shoot in any situation. That said, I do prefer the look of natural light and make every at-

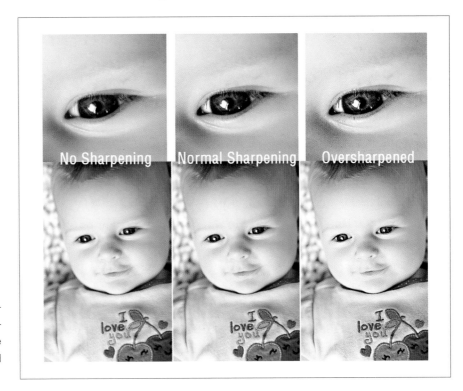

You can see here the vast difference between an unsharpened image and an oversharpened image; at a certain point the sharpening will actually increase noise and pixelation, which we do not want.

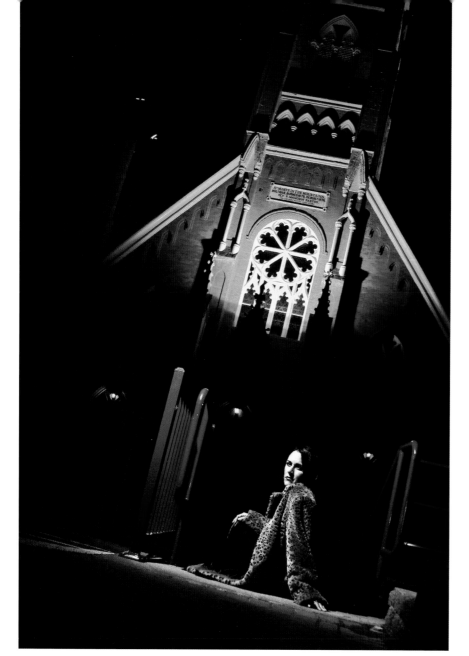

Off-camera flash techniques can be very striking.

tempt to utilize it when I am able (I will discuss different available-light situations in the next chapter).

My studio is set up to use natural window light first and studio strobes as an alternative if the weather or time of day is not ideal. If you will be shooting in a studio situation, you may want to invest in a set of studio strobes or continuous lights—and there are many great options. I have Novatron studio strobes; I use them very infrequently, but they are well made and work well for my needs. I also like the built-in wireless capabilities of the Canon Speedlite system, which I use more often than my studio strobes. I recommend keeping a couple of electronic flash units and a wireless transmitter in your kit. There are some fun, creative things you can do with off-camera flash and small speedlights. A couple of great resources for learning about off camera flash are www.Strobist.com and www.RockThatOCF.com.

My studio is set up

to use natural window light first

and studio strobes as

an alternative . . .

I love the look of natural light and try to use it whenever possible—outdoors, in clients' homes, and even in my studio.

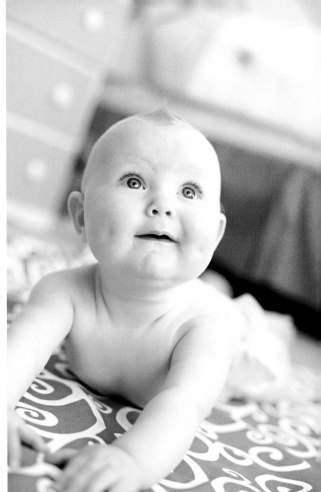

Another necessity for lighting is reflectors. I love to use reflectors to shape natural light. In my studio, I keep a large reflector set up opposite the largest window to bounce light back into the shadows. Some reflectors come with a variety of surfaces; it is a good idea to have a soft white, soft silver, and soft gold on hand.

The BIG Decision: A Studio or Home-Based Business?

I understand the dilemma in choosing whether to work from your home or in a commercial studio environment. Let me share with you my experience in both situations. I opened my business in 2001, working from home part time. After three or four years, I was able to quit my day job and work for myself full time. In the summer of 2009, I opened a small studio in the downtown area of my city. In my studio, I have a natural-light shooting room that is sufficient for photographing children and small families—up to about four people. I also have a gallery area, as well as a small storage and office area and a proofing room. My space is only 650 square feet and I maximize on every inch of space. This studio is perfect for me and the way I do business.

When I was working out of my home exclusively, I brought my backdrops, lights, props, and camera equipment to the clients' homes and set up in their living room, or I shot outdoors. In my studio space, I am able to control the light more effectively and consistently—and to accommodate my clients more efficiently. An added benefit to opening a studio has to do with sales; the studio allows me to proof images with my clients in person via projection and I find it to be a very effective and profitable sales tool. (I will elaborate on the sales session later in this book.)

The benefit of working exclusively from home is that it is very cost-effective and affords you the ability to write off a portion of your monthly mortgage or rent as a business expense. I still maintain an office space in my home;

Working in clients' homes can be fun and exciting—you never know what to expect!

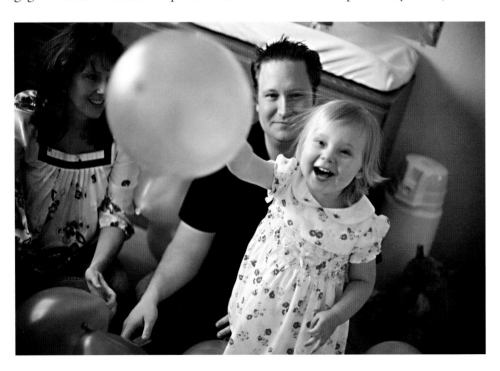

this works well for me and my family. All of my client interactions, however, take place at the studio or on location.

Another great option is a studio co-op in which you share studio space with other photographers. This can be an excellent way to enter into studio photography while reducing the high cost of setting up and maintaining a studio. I have actually made my studio space available to other local photographers to rent for short blocks of time. This has worked out very well for all involved. If you opt for this route, you will want to make sure you are properly covered for any liability issues that may come up. It is also important to establish guidelines for the use of the space and equipment—and to put this in writing to avoid any misunderstandings or misuses of the studio space.

Props, Backdrops, and More

Another benefit to working out of a studio is the opportunity to work with many different backdrops and props. I just love old funky chairs and am constantly buying them secondhand from www.craigslist.org and thrift stores. I also like to use some pretty non-traditional materials for backdrops; I find that this has helped me to keep my work fresh and unique. Some materials

Fabric stores can be fantastic resources for unique background materials.

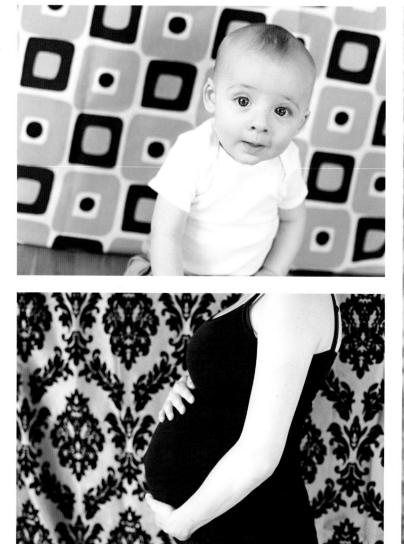

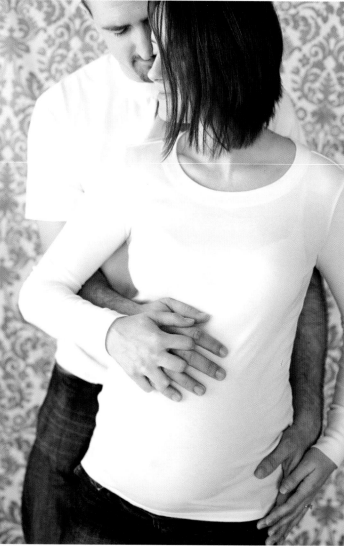

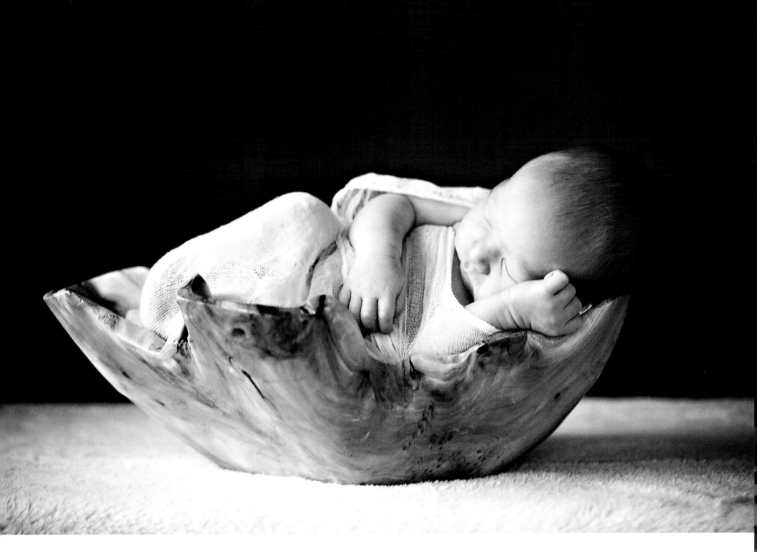

I love this wooden bowl I purchased for $10 at a local closeout store. Some of my clients have looked at me like I was crazy when I pulled it out for their baby—but when they saw the final products, they were pleasantly surprised.

I employ as backdrops are upholstery fabrics in interesting patterns, shower curtains, and bedsheets. Anything with fun colors and an interesting texture can be used as a backdrop.

I have come across a number of independent vendors who produce beautiful backdrops and faux floors; one of them is www.PhotoPropFloorsandBackdrops.wordpress.com. This web site offers some really cool options for spicing up your studio work—as well as custom backdrops for those who want something totally unique.

I love to use www.Etsy.com for photo props and am also constantly on the lookout at garage sales, closeout stores, home décor stores, and thrift stores. These are great places to find unique props. The key is to look for something that you might not immediately think of as a photo prop.

2. Technique

Finding Your Style

Style Sets You Apart. One important way that you can differentiate yourself from all the other photographers out there is to establish your own personal style. This will allow clients to easily identify your work. If your images seem to take on a certain consistent mood, you may have already established your style without even realizing it. If you are constantly trying new methods of processing and editing your images, following certain fads or trends in pro-

LEFT AND FACING PAGE—When clients look at a selection of your images, they should be able to see variety—but also a consistent overall style that unifies them.

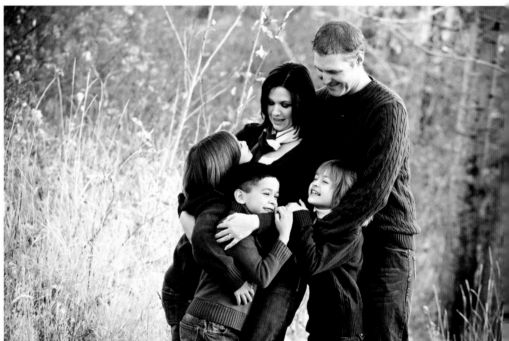

cessing styles, or spending a lot of time trying to learn the newest Photoshop trick, then you may still be trying to find your style. Having a style does not mean that every image will look the same; it simply means that you consistently produce images that evoke specific emotions and capture your clients' personalities in a unique way. For example, if your work is primarily candid and photojournalistic, clients will identify that as your style.

What's Your Style? A good first step when considering your own style is to take a look at your body of work and choose ten to twelve of your favorite images. Those images probably speak to you for some specific reason. Try to identify what it is you like about them. Come up with some adjectives that describe your work—for instance, "fresh" or "emotive." With these adjectives in mind, you will have a handle on what defines your style and be able to consistently match your images to that established look. Keep these words in mind when you are shooting; they will inspire you as you work with your clients and help to solidify your signature style.

My Style: The Lifestyle Portrait. My personal photographic style could be defined as lifestyle portraiture. I will definitely pose my subjects, but then I like to capture what happens as they interact with each other. To me, creat-

Lifestyle portraiture involves both posed and candid images—but the objective is to capture moments and memories your clients will treasure.

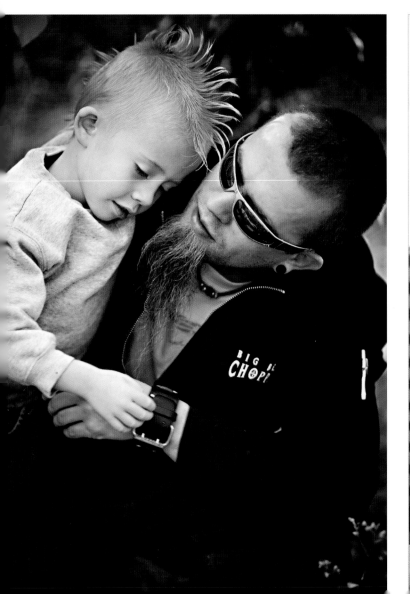

Explaining the relaxed style of my shoots to clients before the session helps them loosen up and be themselves in front of the camera.

I want to capture natural expressions that show who they are at their heart.

ing a good mix of posed and more candid photos is important if you want to truly capture memories that your clients will treasure. When they look back on their images in the years to come, you want them to remember the fun they had during your session—the laughs, the running, the playing—not being forced to smile in a stiff, unnatural pose.

It can sometimes be hard to help your clients loosen up and embrace a less structured session style. People have become accustomed to the traditional way of shooting portraits, so it takes time to make that paradigm shift. But it is happening now—and in a big way. Our industry is filled with fantastic photographers who are working with families in this new way. As a result, consumers are beginning to respond to the shift and appreciate the value of custom photography that is tailored to their needs and to their family.

To prepare your clients for their session with you, and for a more relaxed and free-form style, talk with them in advance. I like to explain that I will not be looking for forced smiles from their kids. Instead, I want to capture natural expressions that show who they are at their heart. I ask moms to give me some space to work with their kids in order to establish a rapport with them; helping them relax and enjoy the session makes it more of a play date and less of a task.

When it comes to family portraits, I like to choose a location based on good lighting. Then I loosely pose the family—usually in a way that feels natural or comfortable to them. I encourage them to talk and play. I may ask the kids to tell their parents a joke or to make faces at each other. Some of the most adorable smiles come right after kids are asked to make faces at each other or their parents.

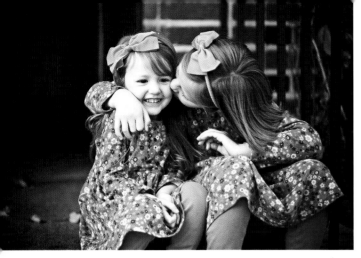

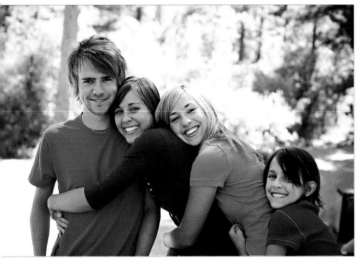

FACING PAGE—Sometimes the most authentic moments are the ones that happen unexpectedly—after the posing is over.

This beautiful girl is sitting on a curb in the parking lot of the park where we were shooting. The light just caught my eye and I sat her down right there.

Working Outdoors

Beautiful Light, Then Beautiful Background. For my personal style, I look for the light first and background second. This method has served me well. It is very important, when shooting portraits outdoors, to keep a close eye on the direction of the light that is hitting your subject's face. The difference between a pleasing effect and an unflattering one is usually just a matter of turning the subject around to allow the light to hit them in a more attractive way. Look for the catchlights in your subject's eyes. The point in the iris at which the catchlights appear will be directly related to the direction the main light is coming from. Watch out for lighting situations in which there are no catchlights in the eyes; this means there is not a main light source hitting them. Your light is either very flat or not bright enough.

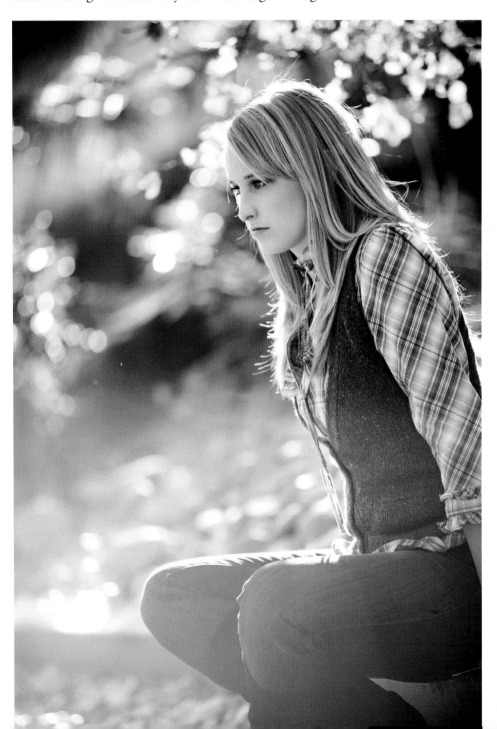

THIS PAGE AND FACING PAGE—To capture beautiful lighting outdoors you must learn to see scenes the way your camera does. The key to avoiding problems is finding lighting that is very even.

To capture beautiful light in outdoor sessions, you must become comfortable seeing the way your camera does.

To capture beautiful light in outdoor sessions, you must become comfortable seeing the way your camera does. The human eye is a far more sophisticated instrument than our cameras, so what we are able to see with our eyes generally does not translate into our images in the same way. For instance, the human eye has an amazing ability to decipher details in a wide range of tones from highlights to shadows. The camera has a far less extensive range. As a result, what you see as just a soft spot of light peeking through the leaves of a tree and landing on a subject's cheek can translate into a very unattractive hot spot in a portrait. The key to beautiful light outdoors is keeping it even. Your subject should be in even sun, lit by bounced sunlight (*i.e.,* off the side of a building), or in open shade without any bright spots hitting their face. For this reason, I prefer to shoot outside before 10AM and after 2PM (depending on the time of year). This will, of course, vary depending on where you live.

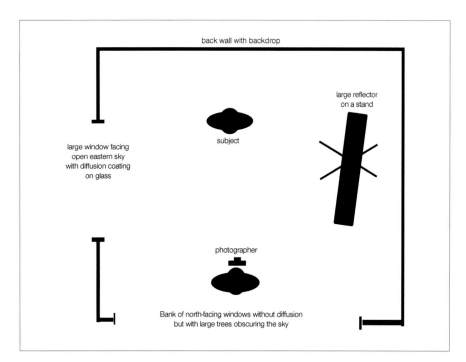

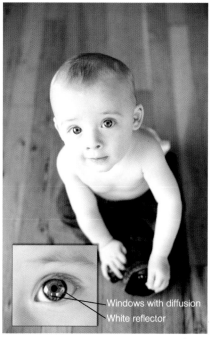

Windows with diffusion
White reflector

In my natural light studio, I am able to utilize large windows and reflectors to create soft natural-light setups.

The larger, brighter catchlights on the left side of the baby's iris represent large windows diffused with a frosted glass coating. The smaller, softer catchlight on the right side of the baby's iris is a 52-inch soft white reflector.

In my natural-light studio, there is one large window to camera left and facing east, plus a larger bank of windows behind the camera and facing north. My studio lighting, therefore, tends to be more directional. As a result, I use a large reflector for fill; this is placed on a stand to camera right. In the photograph above, and in the closer view of the baby's eye, you can see the prominent catchlights representing each window and a softer catchlight representing the reflector.

Shooting in high noon sun can be very difficult, but it can be managed with the right knowledge. In the example below, you can see how I was able to balance sun and fill flash with shade. Even in this case, though, there are

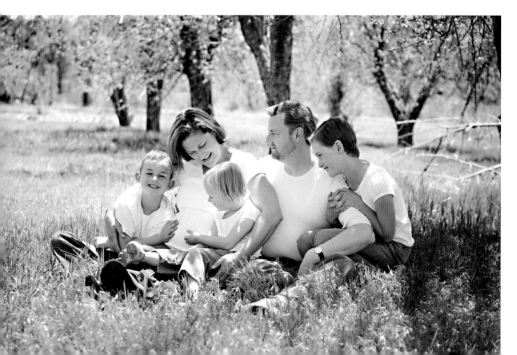

For this family portrait taken at high noon, I posed the family with the sun as much to their backs as possible and under a tree to provide some screening from the direct sun hitting their heads. Fill flash was also used to balance the bright sun. The hot spot on the boy's nose was unavoidable because of the high angle of the sun.

some definite hot spots on the subjects. This sometimes works—but it can be very tricky, so practice is the key.

Another difficult lighting situation may come up when the background your client wants makes it impossible to place the sun behind you or them. In the example below, the subjects are sitting on a golf course and facing northwest. The valley stretches out behind them to the southeast. Fill flash (just off camera right) was needed to balance the direction of the sun. This image was taken at about 7PM, but as you can see from the sample images, it would be nearly impossible to balance the foreground and vast background without fill flash—no matter what the time of day.

Fill flash was needed to balance the subjects and the background. The direction of the shadows and the highlights on the right side of the man's face show that the sun was high and to camera right, providing a very uneven lighting situation. In this case, accomplishing the vast view of the mountains and valley that the client requested required fill flash. Changing to another angle of view would not have satisfied her request.

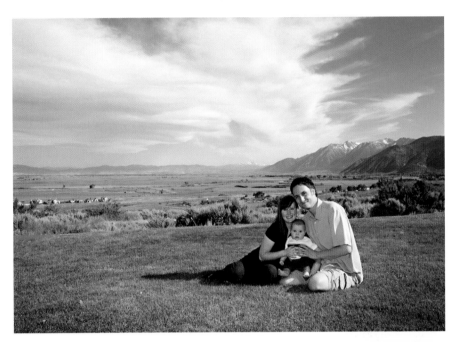

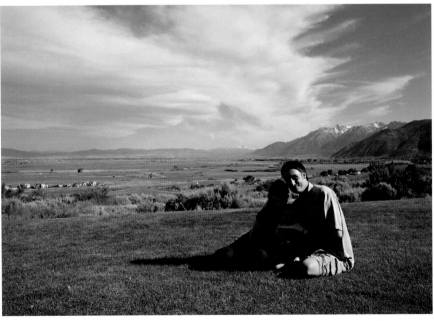

Backlighting is something I strive to use as often as possible. The trick to capturing beautiful images with backlight or soft, haloed light is to place the subject in front of a background that falls within a similar exposure range. Then, let the sun hit them from behind and a bit above so their hair is haloed but their face is in open shade. You will want to meter for the face and make sure to expose properly so as to render pleasing skin tones. This can result in backgrounds which are blown out and overexposed—but for my personal shooting style, this is not a problem. If you do not like that particular look, you will want to expose for the background and light your subject with fill flash or reflectors. There really is a time and situation for either metering method. Since I prefer to shoot with natural light as much as possible, though, you will not see me exposing for the background very often.

Location Choices. Depending on where you live, you probably have a variety of great choices for locations. My town sits nicely positioned between deserts and mountains—and near one of the most beautiful lakes in the United States. I have a vast selection when choosing outdoor locations, but some of my favorites are an old barn in a rural neighborhood and a county park with a variety of different landscaped areas that are perfect for portraits. I also use the local university campus, our downtown area near the river, the mountains, and the lake. Even the older neighborhood near my downtown studio offers some unique and fun locations for portraits.

The trick is to be constantly on the lookout for new locations and not be afraid to shoot anywhere. Seemingly uninteresting locations can produce some beautiful images if you know how to work the light and your subject. I frequently take time out of my schedule and drag my

The key to using backlighting effectively is to place the subject in front of a background that falls into the same exposure range. As you can see in this soft, golden portrait, the sun hitting the family from behind creates gentle rim lighting on their hair—but their faces are evenly lit by the open shade.

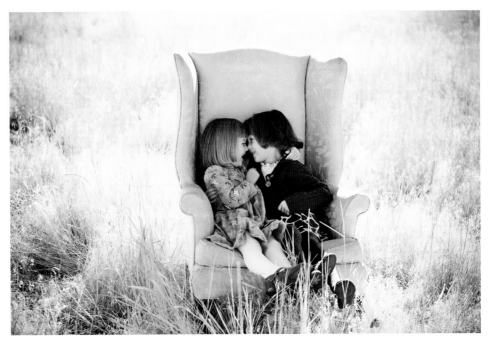

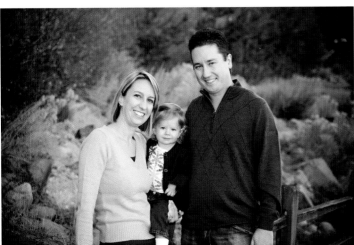

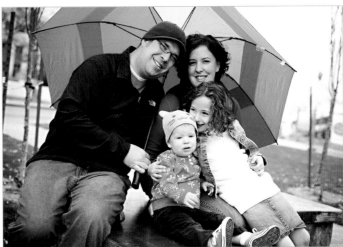

Take the time to do some location scouting so you can offer your clients a wide variety of looks in their images.

personal model (my ten-year-old daughter) along on a location-scouting trip. I am always trying to mix things up and experimenting with new places—otherwise, my work begins to look a little stale to me. Ultimately, you want to be the one to dictate where your sessions take place; you are the professional. If you are confident, your clients will respond and respect your opinion. (Of course, if a client has seen images shot in a specific locale and wants that look, you should happily oblige them.)

Working in Clients' Homes

The high ISO capabilities of today's DSLRs have made shooting in clients' homes much more feasible. I love the excitement of heading out to a client's home and knowing it will be an utterly unique shooting location. There are always special areas to photograph the family. An added bonus is that their images will be even more significant because they represent their lives in such a personal way.

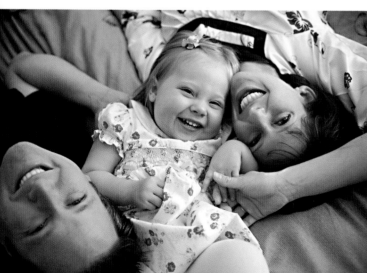

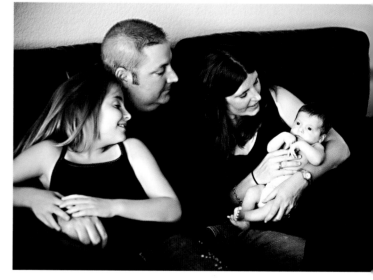

When planning a home session, let the clients know in advance that you might want to shoot in any area of their home—that will allow them time to tidy up, if necessary. Bedrooms and family rooms are great choices and make families feel at ease.

Evaluating the Light. Some special considerations with shooting in clients' homes may include the lack of control you will have over lighting quality and color, working with pets, and learning to be comfortable asking clients to move furniture for the portraits. Many clients will have an idea of where in their home they would like to have portraits taken; sometimes, however, these locations will not be the best for lighting. As I noted earlier in this chapter, lighting is much more important than the background. Try to prepare your client in advance of their session by letting them know that you will be asking to see all the rooms in the house to determine the best light. This will avoid the potential embarrassment if certain rooms are not tidy and ready for photography.

It is also a good idea to speak with clients in advance about the direction their windows face. This can help you plan the appropriate time of day to hold their session. If the home has many large windows facing due west, I would not recommend shooting there late in the day. At that time, the light will be harsh and hard to control. A morning or early afternoon session would be a better idea. Naturally, the opposite is true for east-facing windows. North-facing windows are great all day long in the northern hemisphere; south-facing windows are, accordingly, good all day for the southern hemisphere.

Locations to Try. Portraits of kids in their own bedrooms can be very fun. Most children love to show off their stuff and will enjoy the personal attention they

get. Backyards can be nice—especially if the yard has some sort of play structure (trampolines are particularly fun for kids and grownups alike). I also love to take portraits of families flopped down on Mom and Dad's bed—cuddling, reading, having a tickle fight, etc. Big, comfy beds are also great for baby and maternity portraits—so encourage your clients to allow you to shoot in their bedrooms if the lighting allows. Other good places can be bathrooms (tubs and showers make clean, simple backdrops) and kitchens, which usually have beautiful light and nice floors.

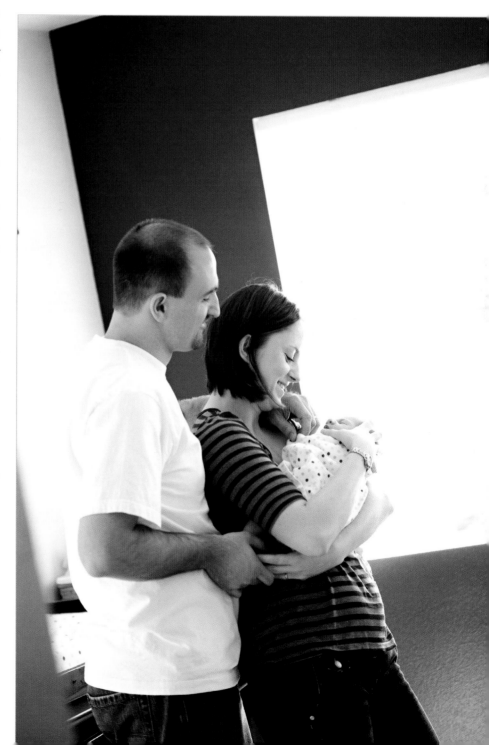

Lighting is more important than the background— but here the coordinating cool tones of the wall and the parents' clothes make the warm skin tones the focus of the image.

3. Working with Families

Beginning the Relationship

Beginning a relationship with a potential client should be more like striking up a new friendship and less like striking a business deal. You certainly should be compensated for your work, but I believe that when your clients care about you and know that you care about them, they tend to put greater value on your unique artistry and will gladly pay to have your work.

Think about the way you treat a new friend. You want them to like you and will go out of your way to make them happy and do things for them. As the friendship grows, you will send birthday cards, call just to see how they are doing, and keep up with their lives—and you will share your life with them as well. The idea of relationship marketing is just that: treat your clients like you would your friends. I will expand on this more in later chapters, but remem-

People are loyal to brands with which they have formed an emotional connection. Therefore, the best client relationships are much more like friendships than business partnerships.

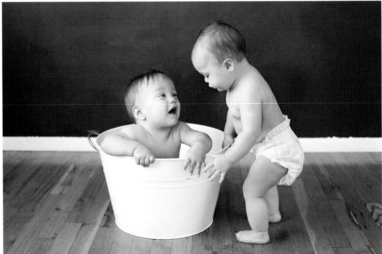

Images that portray the innocence and beauty of their child will speak to parents in a profound and heartfelt way.

ber this: people are loyal to the brands with which they have formed an emotional bond.

In his book *Lovemarks: The Future Beyond Brands* (PowerHouse Books, 2005), Kevin Roberts talks about the idea of building loyalty beyond reason—loyalty that will make your customers choose you even when they have to go out of their way to do so. I have a beloved client who lives about 45 minutes out of town. This may not seem like a lot to those of you from larger metros, but in my town it takes 15 minutes to get anywhere—so the 45-minute drive from her town to mine is a stretch for some people. Rather than use a photographer in her town, though, she will come into my town for her sessions. In fact, she has driven two hours for a session before. That's loyalty.

The Consultation

I try to have a consultation with every client before I work with them for the first time. This allows me to share my vision with them, to get to know them a little, and to decide if we are a good fit. (I may conduct the consultation in person, but usually this happens over the phone.)

Qualifying the Client. Sometimes, what clients are looking for is not what I offer—and that's okay. I get occasional calls that go something like, "Hi, my name is Mrs. Smith. I am looking for someone to take portraits of my little Johnny. I just need two 8x10s and eight wallets and I can spend $100, please call me back." I absolutely respect that this particular parent knows exactly what she wants and what she is willing to pay for it. However, I am not what she is looking for. I will call her back, explain what I do and what she could expect to pay for it. If she replies that she is not looking for that type of service, I will refer her to the local high-volume portrait studio.

There is no reason to take every client who comes to you—or to compromise on what you do and what you charge for your sessions. Be confident in your pricing and style and you will be successful; the right kind of clients will come your way.

Educating the Client. During the creative consultation, I discuss my pricing and studio policies. I also talk with the client about style and set appropriate expectations for turnaround times and the session structure. I send out a digital copy of my info sheets via e-mail; then, if they book, I follow up with a welcome packet sent in the mail. This includes information and pricing as well as a form to fill out with their personal information for my records.

Having clients identify images that appeal to them on your web site can be helpful to you when trying to establish a plan for their portrait session. This will allow you to effectively balance each client's unique expectations with your own vision.

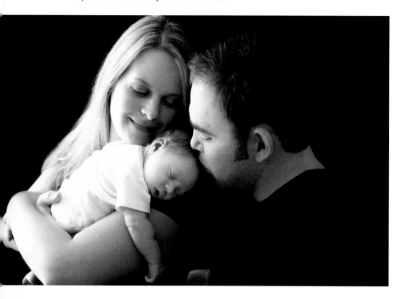

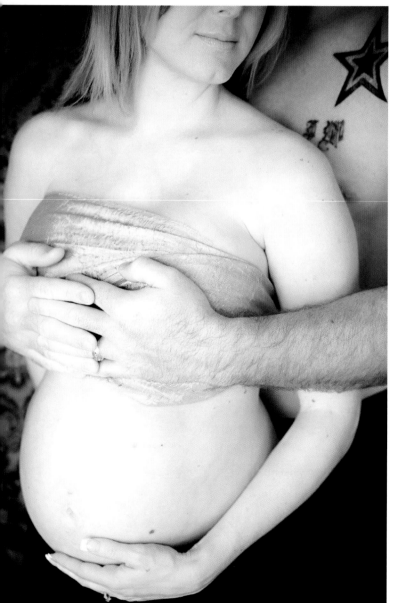

Collecting in Advance. I collect a session fee or package deposit in advance. This helps the client to take the session seriously; I get far fewer cancellations once the client has made a financial investment. I also offer a discount on prepaid packages. Encouraging the client to pay in advance for their print collection makes the sales session go very smoothly since we know what we are looking for in the proofs.

Sharing Your Vision

Before you meet with a client for their session, establish a vision for their portraits. To do this, you will want to question them about what they are looking for and where they plan to display their images. Having them identify images on your web site that they are particularly fond of will help you to see what they are reacting favorably to when they look at your work.

From this point, you will want to formulate a plan for their session and share this with the client. Describe to them, using personal adjectives, how you see the session unfolding. For example, you might say: "Mrs. Johnson, I hear you saying that your little girls are imaginative and angelic, and that they like to pretend to be princesses. What I see for them is a session with a soft flowing wardrobe—sundresses or maybe even some dress-up clothes—and your girls playing together in a garden. The pictures would feel very serene and innocent—a perfect depiction of the stage they are in right now." By using words like "imaginative," "serene," and "innocent," I have evoked her adoration for her young children and begun the process of building an emotional connection to my work and to my studio. This is done even before the first shutter click.

Shooting with the Client's Expectations in Mind

It is important to remember that our business is based on our relationships with our clients and their relationships with each other. With this in mind, it is imperative that you always consider the client's expectations in conjunction with your own vision. If your client raves about the

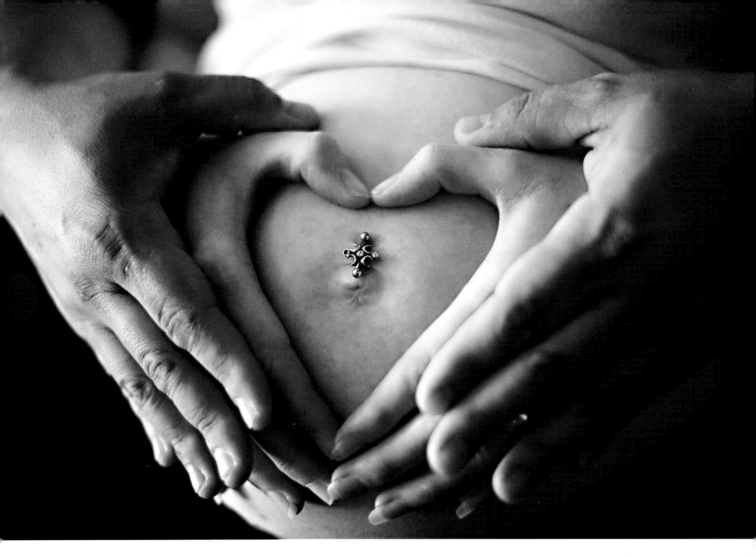

A shot like this may not feel fresh and new to me—I have created similar belly images many times—but the client will only have *their* version.

close, cuddly shots of a mom and toddler you have on your web site but you only deliver stiffly posed or very wide shots, you are not considering her taste—and, likely, ignoring the reason she hired you to begin with. I cannot tell you how many versions I have in my archives of the belly-and-hands shot seen above. I have done it time and time again—but while it may not feel fresh to *me*, the client will only have *their* version. If they love it, then it is my job to honor their expectations and capture it for them.

This thing we do as photographers requires us to strike a delicate balance between art and service. A truly talented photographer knows how to balance their clients' desires with their own artistic vision in a beautiful dance of creativity and expression. Think of the collaboration between you and your client as a complex musical number. Every instrument adds its own special sound to the finished product, resulting in a feast for the ears. Photography is a feast for the eyes—a moment frozen in time that represents the complex relationship between subject and artist. The most rewarding experience in this job is the moment when I reveal the proofs to my client and they respond, "That is *exactly* what I wanted!"

To Everything
There Is a Season

Every family passes through seasons. In the beginning, two people join together and promise to build a life together. Eventually, they decide to bring new life into the world. Then, there is a special significance to each stage those precious little ones pass through on their way to adulthood—when they will build lives and a families of their own. The circle keeps on repeating.

My goal as a photographer is to be there for my clients as they travel through life, to capture their family history in beautiful and unique fine-art images that will stand the test of time. I want them to see me as someone who will be there with them through the years—in the same way they have a trusted family doctor or a favorite realtor. I want to be their photographer for life.

The following chapters will discuss each specific season and how you, as a photographer and businessperson, can work with families at each stage to help them build a record of their family. As you'll see, your relationship with your customers must grow, change, and deepen through the years.

Why We Are Not Talking (Much) About Weddings

You may be wondering, at this point, whether or not I photograph weddings. The answer is yes—I do take about ten to twelve weddings per year, but no more. I am not covering weddings in this book because there are already so many amazing, informative, and inspiring books on the subject. My wedding business is an amazing source of family photography clients—in fact, weddings enter into the cycle of seasons on many levels. I have clients continue with my studio as they start their new lives together, coming back for maternity, then newborn portraits, and so on. I also get many referrals from wedding guests, friends, and family members of my couples. My wedding business is a treasured part of the overall picture of my studio and I think I will always shoot at least a few weddings a year.

If you have a passion for photographing weddings and would like to expand into that market, I encourage you to work as a second shooter for at least one wedding season before you attempt to book and work weddings on your own. This is a very important time for developing your confidence—and your portfolio. I also encourage you to read everything you can get your hands on with regard to wedding photography. I built

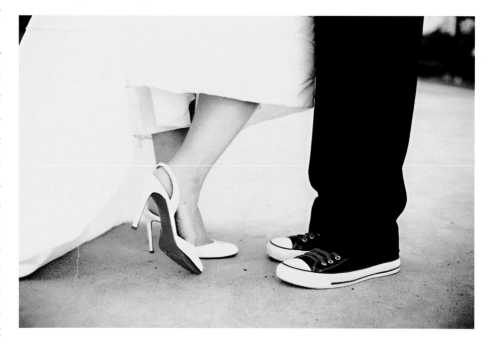

Wedding photography is an important part of the overall picture of my studio—but it is a different animal than portrait photography.

my business and expertise through reading many of the excellent books on the subject and learning from other photographers.

Wedding and portrait photography are two very different animals. Do not assume that because you are great at capturing families and children you will be equally well-suited to the fast-paced and sometimes very stressful environment of wedding photography.

4. The Beginning of a Family

The Miracle of Life

I love maternity sessions. As a mother myself, and one who truly loved being pregnant and learning about the miracle of what my body was capable of doing, I have an intense respect for pregnancy. A woman's body is an amazing thing, and I adore the opportunity to capture images of this fleeting and very special time. More importantly, I think of it as my job to help the mom-to-be see herself as beautiful during a time when she really may not *feel* beautiful.

Sharing my enthusiasm for pregnancy has been a catalyst for growth in my business. In fact, the writing of this book was originally inspired by my love of maternity and newborn photography. The connection I am able to establish

It's my job to make the mom-to-be look beautiful at a time when she may not be feeling very beautiful.

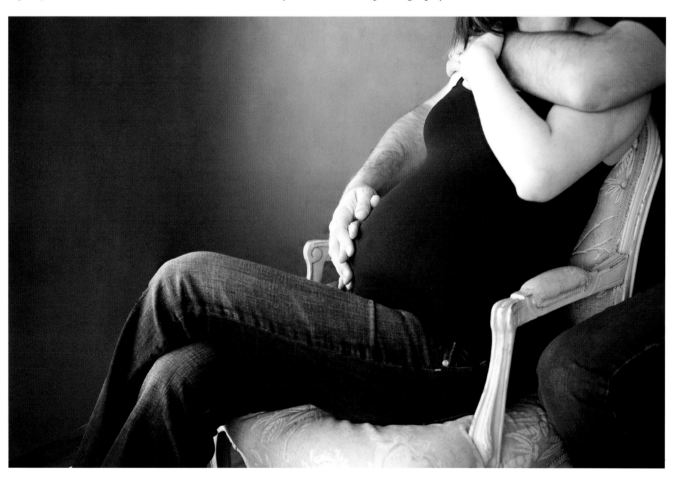

with my clients through capturing this very special time in their lives is unlike any other. I worked for years as an organizer of a mothers group and have always felt that the bond women share in their roles as mothers is very strong. This is not to say the male photographers can't share in this bond as well, but I find that women deeply connect with each other over the trials and tribulations of motherhood.

The miraculous and exciting adventure of bringing new life into the world makes a woman begin to evaluate who she is and her purpose in life. Her body is changing rapidly and people are suddenly reaching out to touch her stomach (usually without permission). She is the center of attention wherever she goes. On top of all the physical changes, hormonal changes will leave her feeling emotionally drained and defeated at times. For all these reasons, it is important to establish a connection with your maternity clients, helping them realize how beautiful and precious they are. Bringing joy and confidence to a woman who is carrying new life is a singularly precious gift—and this is why maternity portraits are such a huge part of my business.

Marketing to the Expectant Mother

Networking and Word of Mouth. The unique nature of maternity photography makes finding your target market pretty simple. Not only do I see referrals from my blog and social networking sites (like Facebook), I also get numerous referrals from past clients. Many of my clients are actually friends with each other, which is exactly what this relationship marketing thing is all about—creating customer loyalty that inspires them to not only to come back but also to tell their friends.

Play Groups and Mothers Groups. In my days of running a mothers group, I had a never-ending stream of potential maternity clients within my own personal circle of influence. I would recommend that any female photographer who has children join as many play groups and mothers groups as possible—but make sure that you are there to make friends, not just to market your business. Otherwise, people will sense your ulterior motives and reject your attempts.

Maternity Service Providers. Another fantastic way to market yourself to expectant mothers is to form alliances with obstetricians' offices and 3D ultrasound providers. Offer to furnish some beautiful artwork for their offices at no charge and provide them with a supply of gift certificates for your services. They will seem generous for distributing these gifts to their patients and you will get plentiful referrals for very little overhead—basically, just the cost of the prints and gift certificates. I am very comfortable giving away free session fees to bring in ma-

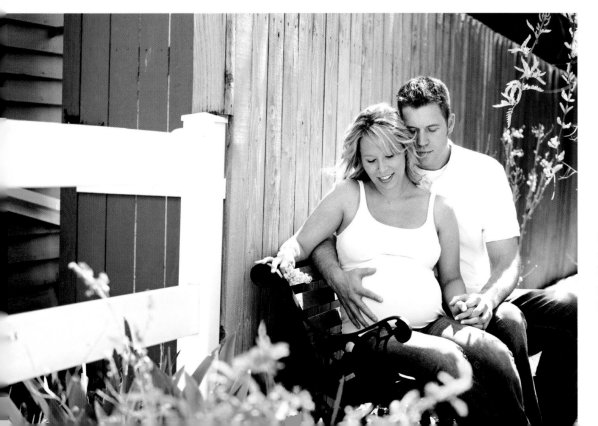

Social networking sites and client referrals are especially important in the maternity photography aspect of my business.

TOP—When your clients love their maternity portraits, you can bet that they'll be back to your studio for newborn images—and additional images as their child grows.

BOTTOM—Intimate moments between family members make some of my favorite images. Even though the son's face cannot be seen here, his presence in the scene is not diminished at all.

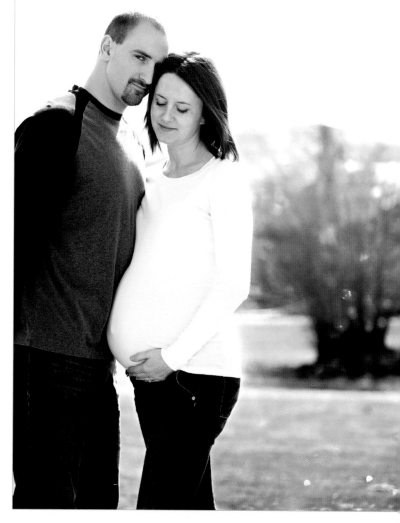

ternity clients; I know they will love what I do for them and soon return for newborn and first-year portraits. Another great avenue is to distribute your information and gift certificates to maternity clothing stores, Lamaze centers, venues with birthing classes, and gyms that offer classes or programs for expectant mothers.

Social Networking Sites. Social networking can be a very effective marketing tool (in fact, I will discuss it in more detail later on). Sharing your photos with your clients on Facebook is one of the quickest and cheapest ways to put your work in front of hundreds of potential clients. I provide low-resolution, watermarked digital files to all my clients via my blog and Facebook business page—and I always receive at least a few additional "likes" on my business page from each client. Women love to talk about their excitement over expecting a baby, and then about their new sweet angel when the child is born. Engage with them on these social networking sites, comment on their posts and share your advice and congratulations. This is what friends do. This brings you and your client closer than the one or two phone or e-mail conversations you would have otherwise. Relationship building is, at its core, about engaging with others in their lives. You cannot fake this, so be real with people and you will be amazed at how their loyalty will grow.

Planning the Maternity Session

Evaluate the Client's Desires. Once your client has decided to book her maternity session, schedule a consultation with her. It is very important for you to decide what type of maternity client she is. Is she comfortable with her body (someone who will not have a problem with bare-belly shots or even mild nudity)? Is she feeling uncomfortable with the weight she has gained (someone

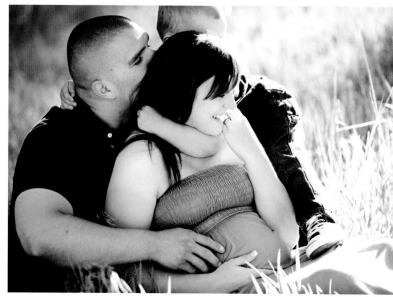

who will want to stay covered up more in her portraits)? Determine what type of portraits she is looking for and whether she has any specific poses in mind or ideas of her own. Many of my clients have seen my work on their friends' Facebook pages or my web site and blog, so they have an idea for a specific pose that they would like. I am always happy to oblige.

Clothing Selection. Make sure to discuss clothing with your client and whether or not she will be bringing other children and/or her spouse to the session. If so, discuss their clothing options as well. I advise my clients to keep their clothing simple; neutral and solid colors are preferred. To avoid leaving marks, I suggest that Mom avoid any tight-fitting elastic across her belly for the day of the session. I keep a few belly bands in the studio, which subjects can wear as tube-tops, and also recommend my clients bring in a few different tank tops and sports bras for bare-belly shots. For family members, I will discuss the option of bare skin for smaller children, toddlers, and babies. If he is comfortable, the husband can be shirtless as well. I also like to have everyone bring in solid white and black shirts for a coordinated look. For outdoor maternity sessions, I recommend bringing a few clothing options; colors can be very pretty in natural scenes, and I love to see women in flowing skirts or sun dresses.

Solid colors are ideal. Here, a vibrant red dress stands out from the almost monotone background to make a dramatic statement.

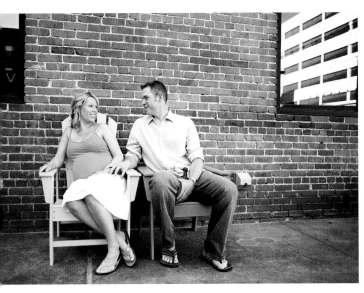
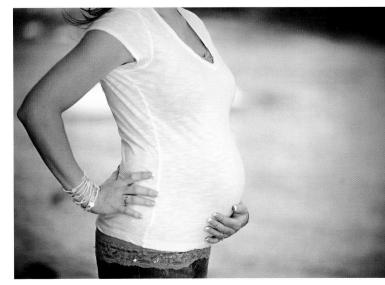

Picking the best location for a subject's maternity portraits will have a lot to do with their personality. Some women prefer urban settings, others love the great outdoors.

Props. Props can be fun with belly pictures. Some items I might ask my clients to bring are ultrasound pictures, wooden letters spelling the baby's name, or some significant toy or stuffed animal they have purchased for the baby. I try to keep belly pictures pretty simple, so I will not normally ask that they bring along too many props—but a few special items can be nice.

Location and Scheduling

When scheduling a maternity session you will want to take into consideration the type of location your client would prefer. I like to mix indoor and outdoor locations for most of my maternity sessions—unless the client would prefer to stay indoors exclusively. Most of the bare-belly shots and all of the semi-nude or wrapped poses will be done indoors in the interest of modesty. Picking a location for maternity portraits will have a lot to with the client's personality and style. I have photographed maternity sessions everywhere from urban settings (alleyways and trendy outdoor markets), to a run-down shack, to overgrown fields. Making sure to carefully consider your client's personal style when making a location selection will help promote the relationship you are trying to build. It will show your client that you really understand her.

Posing for Every Mother's Body Type

Posing is one of the most important parts of photographing a pregnant woman in a way that makes her feel and look beautiful. Some mothers are very comfortable with their pregnant bodies; others are very uncomfortable.

To me, poses that involve shooting from a high angle will result in a pleasing look for any woman. I like to have my a pregnant subject sit or lounge on a couch, bed, or pillows on the floor (sometimes even the ground), then photograph her from above (over her head). This angle keeps the focus on her face when she is looking at the camera and on her belly when she is looking down.

High-angle shots are flattering for every woman—and can be transformed into a pose with the husband (see next page).

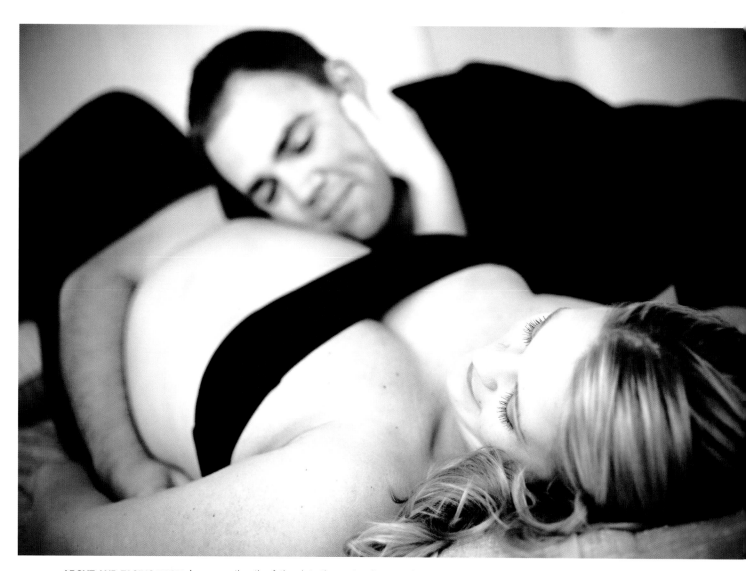

ABOVE AND FACING PAGE—Incorporating the father into the maternity portraits can create especially meaningful and emotional images.

This pose can also translate easily into a pose with the mother and father, as you can see above. Incorporating the father into the portraits allows for some beautiful and touching images. There is a certain way a man looks at his wife when she is carrying his child. It is something like admiration mixed with adoration—and it can be very heartwarming. Most couples are not often photographed together after their wedding day, so maternity portraits are a perfect time to capture their love and bond.

Posing women who are feeling self-conscious about their bodies takes a special ability to listen to the client. I recommend engaging in a conversation with your client about her comfort level, how she has been feeling, and how her pregnancy has been going. During the course of this conversation, she will often mention any specific areas of discomfort. If a mother shares with you that she is

feeling like her "love handles" are huge, you will want to avoid shooting her belly straight on; that will only draw attention to her hip area. If she tells you she feels like her arms are "looking fat," you will want to use poses that do not draw attention to this area. The same thing goes for stretch marks and other blemishes that may appear on the stomach itself. If she is not comfortable baring her belly, you may want to focus on wrapping and draping as an alternative to bare-belly shots.

Wrapping, and Draping, and Backgrounds—Oh My!

As I mentioned earlier in this book, I am a fan of unusual backgrounds—and maternity sessions are no exception. I recommend that my mothers choose neutral or solid colored clothing for their sessions; I use such busy and col-

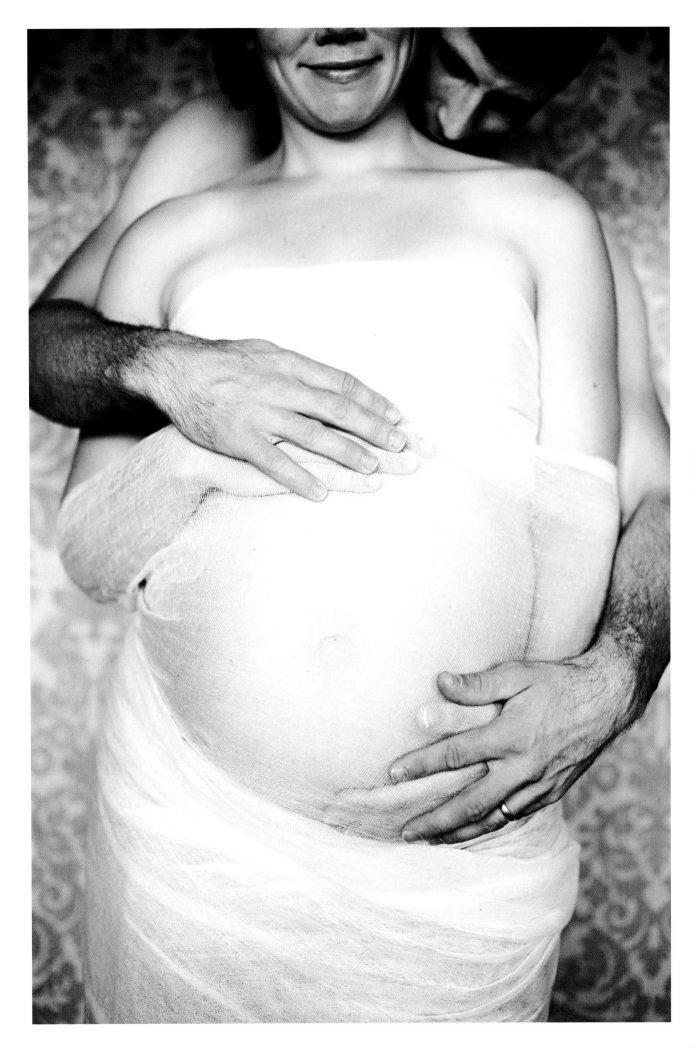

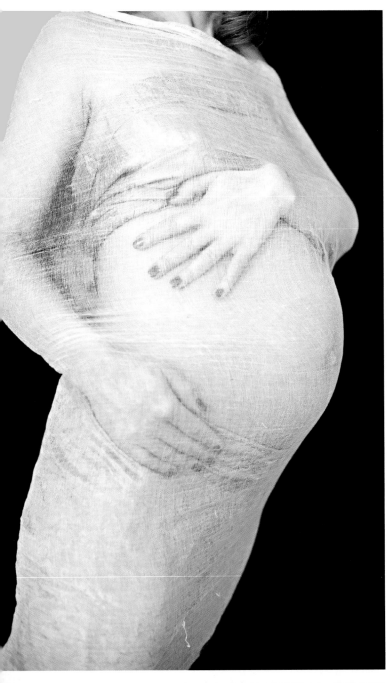

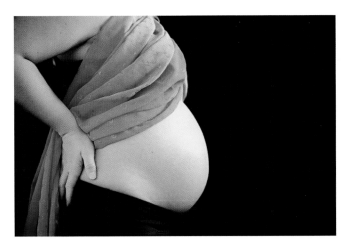

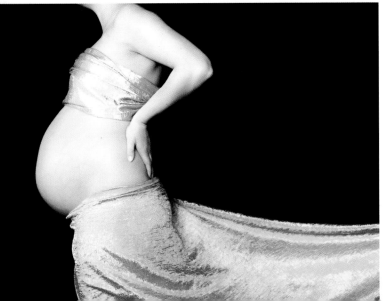

TOP LEFT—Cheesecloth makes a great wrap, offering texture and translucence.

BOTTOM LEFT—Sheer window drapes can also be a wonderful material for wrapping. The lengths offered for window swags are perfect.

TOP RIGHT—Fun, colorful fabrics suit the personalities and styles of many soon-to-be moms.

BOTTOM RIGHT—Playing with fabrics lets you unleash your inner fashion designer.

orful backgrounds that I don't want to end up with overly busy portraits. Any colorful and fun fabric can make a great backdrop, as can the murals, painted walls, and fences found in outdoor settings. I would caution you, however, that not all fabrics photograph equally well. In fact, there are some fabrics I loved in the store that ended up looking just awful when I photographed them. What I have found is that the more reflective a fabric is, the more uneven it will look in pictures. Another consider-

ation should be how susceptible to wrinkling the fabric is. I have a beautiful teal linen that I never use because it is always wrinkled—and it takes too long to steam the wrinkles out each time I want to use it. The one sure-fire fix for most wrinkle-prone fabrics is to store them hung up, but not everyone has the luxury of storage space for this.

Wrapping and draping a pregnant woman can be a fun exercise in fashion design. It also allows you to customize the fit of her "garments" to draw attention away from any problem areas you know she won't want to see in her portraits. Some of my favorite fabrics for draping are sheer cheesecloth, chiffon, and other sheer and soft fabrics. I have even found that window curtain swags can make fantastic drapes for maternity portraits. Safety pins and spring clamps (found at your local hardware store) are very helpful for securing the fabric when you are done wrapping her.

Editing the Maternity Session

You may encounter some special considerations when editing images from a maternity session. Many women will have stretch marks on their stomachs—and women with darker completions may have a dark line running down the center of their stomach. Most women will not object to your removing their stretch marks; however, I would wait to be asked to remove the line. In addition to retouching the stomach, you may need to retouch blemishes that can occur on the mother's face as a result of her pregnancy hormones. Do not overdo the retouching; there is a very fine line between flattering retouching and making your subject look unnatural. I also recommend that you think about purchasing a retouching plug-in or action. I really like the ProRetouch action from Totally Rad Actions (www.gettotallyrad.com). It does a great job of smoothing skin while allowing natural texture to show through.

Black & white conversions can do a lot to enhance the beauty of maternity portraits. I usually convert at least 20 percent of the proofs to black &

You may encounter some special considerations when editing images from a maternity session.

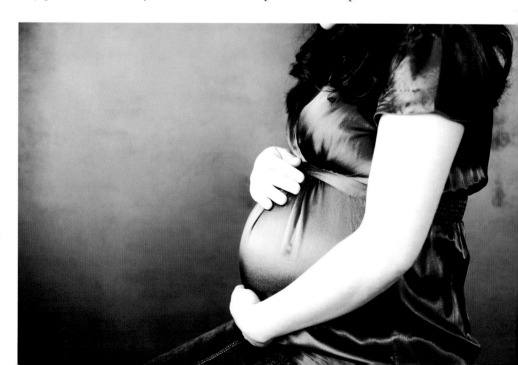

Black & white conversions offer a beautiful presentation for maternity portraits.

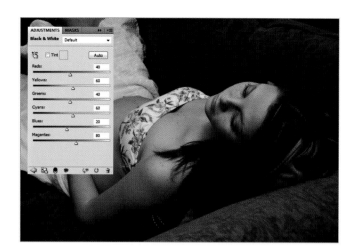

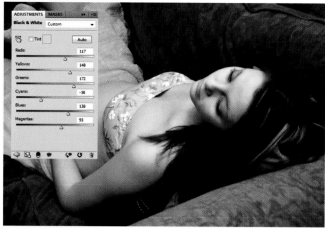

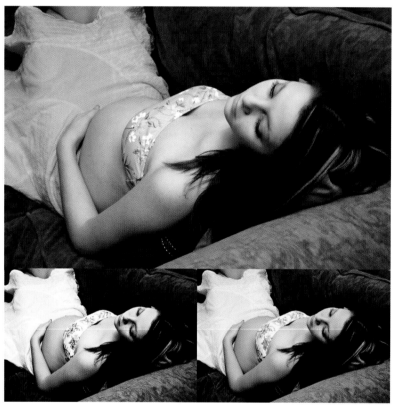

TOP LEFT AND RIGHT—As you can see in these screen shots, by adjusting the color sliders I am able to achieve a very pleasing black & white conversion.

LEFT—Here you can see the difference between the custom black & white conversion achieved using an adjustment layer (top image) and two favorite actions. The left image is Bronzed God 1 from Kevin Kubota's Artistic Actions III set. The right is Bitchin Black and White plus Antique Tone from the Totally Rad Actions set. All three conversions result in a pleasing image.

white using one of my favorite actions from Totally Rad Actions or Kevin Kubota's Artistic Actions. For a great straight black & white conversion, adjust your color image as needed to achieve a pleasing look. In Photoshop, go to Layer > New Adjustment Layer > Black and White. Then adjust the color sliders until you achieve an image with nice black & white tones. I will usually brighten the reds, oranges, and yellows a bit and bring down the blues and greens a bit. This method allows you to customize the black & white tones for each image individually—and

I find it produces a very nice effect. For some additional black & white tones and tints, I really like the Bronzed God 1 action from Kevin Kubota's Artistic Actions III set, and the Bitchin' Black and White action plus Antique Tone from Totally Rad Actions.

Products for Expectant Mothers

The maternity session is such a unique offering that you will want to present your clients with an equally unique array of products featuring their portraits.

Signature Albums. Many maternity clients will come back in for newborn portraits. This affords me the opportunity to offer them our Baby Plan (more on this later in the next chapter!). For clients who choose this option a fantastic product is a keepsake album created using their beautiful pregnancy portraits and newborn portraits (White House Custom Color offers a fantastic line of press-printed books and albums with great paper options for the pages). I market this item as a Signature Album, which can be used for friends and family members to write special notes to the mother and baby—and as a place for the parents to record baby's first milestones.

Canvas Portrait Collage. Another very popular product is the canvas portrait collage. A series of collages from each session can be created and printed using a gallery-wrap canvas vendor. I use Canvas on Demand (www.canvasondemand.com) and have been very happy with their quality and customer service. The collages can be grouped on the client's wall for a beautiful fine-art display.

Birth Announcements. Maternity portraits can also be used in birth announcements, placing an image from the maternity session on the front of the card and images of the newborn baby on the inside.

Most of my design projects are accomplished with a great piece of software called LumaPix FotoFusion (www.lumapix.com). This program allows me to quickly compose collages, album page designs, and cards using a variety of creative tools and then export them to a number of useful file formats.

Maternity portraits can be used in albums, wall images, and even birth announcements.

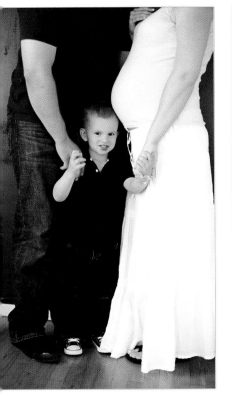
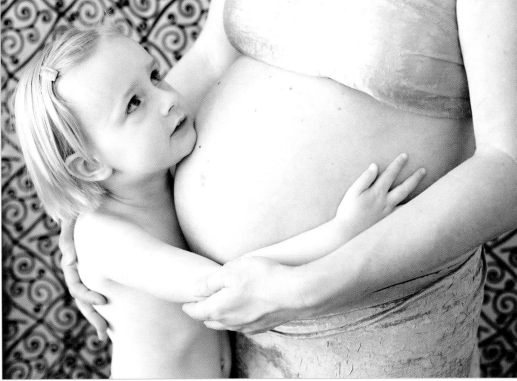

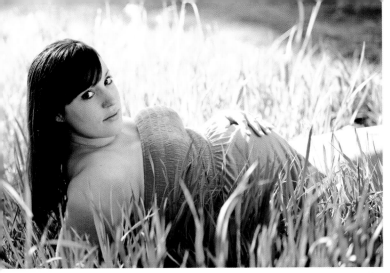

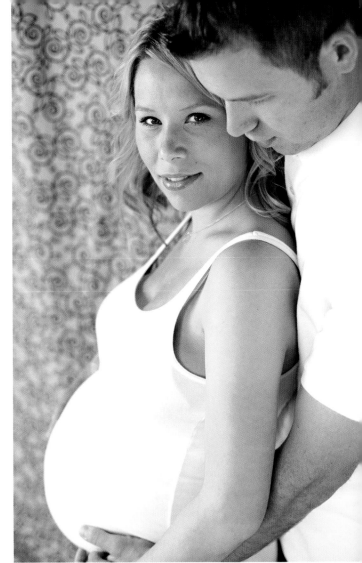

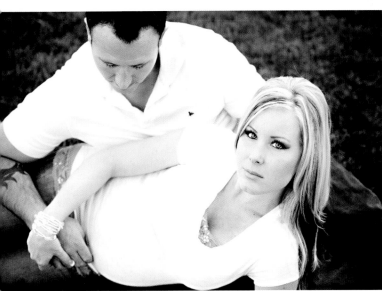

A slide show set to music is the perfect way to present your maternity portraits. I burn a copy of the show to DVD so the clients can share it with their friends and family—great building word-of-mouth referrals.

Proofing the Maternity Session

I use projection proofing in my studio and find it to be an effective method of presenting and selling my photographic work. During the proofing session, I open by playing a slide show of my favorite images set to soft music. Royalty-free music is available at very reasonable rates these days on stock music sites such as Triple Scoop Music and Broken Joey Records. I use Photodex ProShow Producer to create my beautiful, moving slide shows very easily. This presentation is also burned to DVD and offered to the client for purchase (or as a minimum-order incentive) at their proofing session. Many clients love to take the slide show DVD home and show it to their friends and family members—which, incidentally, is a very effective method of word-of-mouth advertising.

Once the slide show is finished playing, the client is hopefully very excited to see all the proofs. We proceed with the proofing session using TimeExposure ProSelect, narrowing the full proof album down to around twenty of their favorites. I recommend my favorite images and suggest wall groupings and collage designs. ProSelect makes it easy to show clients multiple images at once and compare to select their favorites.

During the proofing session, I use Rock the Walls templates by the Life Art Design Shoppe to present a design plan for wall groupings. If the client is not interested in a wall gallery, or would prefer to display single images, I use ProSelect to project the images at actual size; allowing me to compare different sizes usually results in up-selling the print.

Print and product orders are entered directly into ProSelect during the proofing session, via an ordering form that is only visible to me on my computer screen. At this time, I also show the client some album and book options—and present the newborn portrait and Baby Plan options. I offer a discount on these collections if they are purchased at the proofing session.

Introducing the Client to Your Baby Plan

One of the major benefits of shooting maternity portraits is the opportunity to speak with the client about newborn portraits and begin to share the Baby Plan. I offer a free newborn session (within the first two weeks after birth) with the purchase of a Baby Plan collection. As you can see, the maternity session begins the process of connecting this new family with my studio. We have an opportunity to talk, and they can get comfortable with my photographic abilities—and know what kind of work and experience to expect from my studio. I believe it is very important to introduce the Baby Plan with the maternity portrait offerings; I want my clients to plan on bringing their new baby back every few months to record their first year properly.

Birth Photography: A Niche Service

Many parents are so wrapped up in the process and drama of the birth that they forget to document what is going on. Therefore, at the time of the maternity proofing and sales appointment, I inform the client that I offer limited birth photography bookings. Birth photography can consist of full labor-room coverage, where I act as a fly on the wall and document the action of the day, or it can simply be hospital pictures after the birth. In either case, I am very careful to stay out of the way of medical staff and family. To be unobtrusive, I use very fast lenses that allow me to work with the available

The client's proofing session for their maternity portraits is a great time to talk about what comes next: baby portraits!

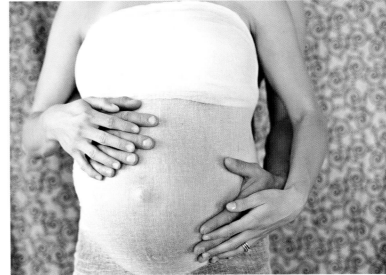

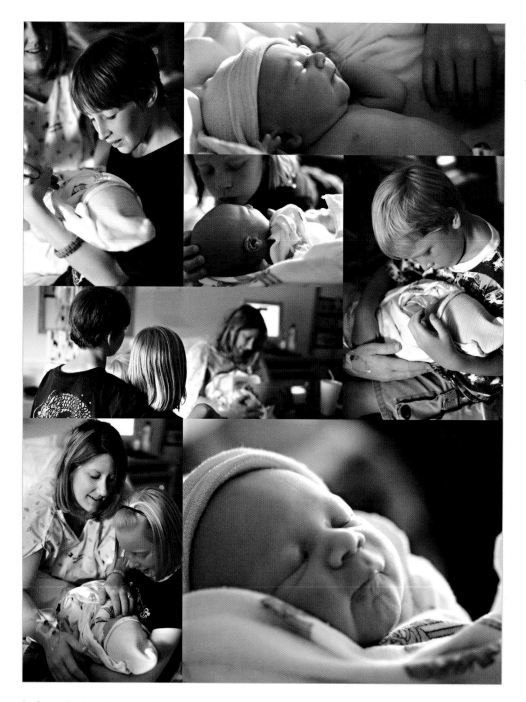

Birth photography can include everything from full labor-room coverage to simply hospital pictures after the birth.

light only (as the use of flash can be very bothersome to women in labor and to newborns).

If you are interested in covering births, keep in close contact with the family as the due date approaches—and be prepared to go to the hospital at all hours. Hospital photography after the birth is a bit less time-sensitive, since most new mothers and babies will spend at least one full day in the hospital before going home. This means you can usually photograph the family during normal working hours. If the new baby has older siblings, this is a great opportunity to capture their first interactions with their newest family member.

Newborn Photography

There is something so sweet and innocent about newborn babies—it just tugs at your heartstrings. I adore everything about these treasured little ones and consider it an honor to be asked to capture their beautiful features in these early days. Newborn photography can be very intimidating for many photographers, and I will admit it was for me for many years. The secret to capturing fantastic newborn portraits is keeping baby warm, fed, and sleepy. I will be discussing some tried-and-true techniques to help you capture beautiful newborn portraits in every session.

Keeping the newborn warm, fed, and sleepy is key to capturing great portraits.

Working with First-Time Parents

One challenge when shooting newborns is dealing carefully with the parents. First-time parents are just figuring everything out. Their baby is a new and precious addition to their lives—and, in their eyes, very fragile and sensitive. New parents will need your reassurance and to see that you are confident in what you are doing to feel comfortable during the session. I provide a calming environment for the new family by turning down the lights in my client lounge area, playing soft music, and sometimes utilizing relaxing aromatherapy. Babies are very intuitive and will pick up on their parents' moods, so the more relaxed Mom and Dad are, the more relaxed the baby will be.

A calming environment during the shoot will make both the baby and the new parents feel more at ease.

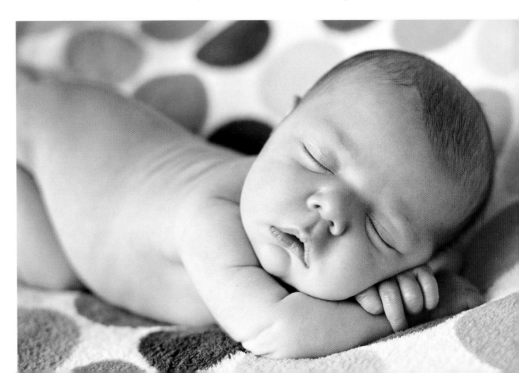

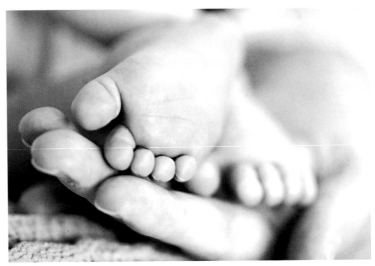

When preparing new parents for their baby's newborn session, I advise certain steps to help the session go more smoothly. First, I suggest that Mom hand the baby over to me for undressing and posing. The baby is accustomed to her scent and the sound of her voice and may want to eat rather than fall asleep, even when he or she is full. I will also ask that they bring along any special blankets, hats, booties, and even small toys that they may want to incorporate into the session. I advise against bulky outfits for newborns; nude and diapered (or covered diaper) shots are preferred. Newborn clothes

You can't go wrong with detail shots of cute little toes—especially when combined with something for scale. Mom and Dad's wedding rings or the feet/hands of a family member add another layer of meaning and show just how tiny the newborn is.

tend to fit loosely and can easily become bunched and look unkempt. Finally, if the baby has siblings, I will try to incorporate them in some shots—provided the older siblings are cooperative. I will also try to capture images with Mom and Dad if they are interested.

Equipment for Posing and Soothing Newborns

As I mentioned before, the key to capturing beautiful newborn portraits is to keep the baby warm, full, and sleepy. Newborn babies are the most sleepy in their first two weeks; the younger they are, the better they will sleep during their session. In addition to being sleepi-

er when they are younger, they will also be much more flexible and better tolerate some very cute curled-up and cuddly poses. Advise Mom to feed the baby just before their session, preferably at the studio or just prior to be-

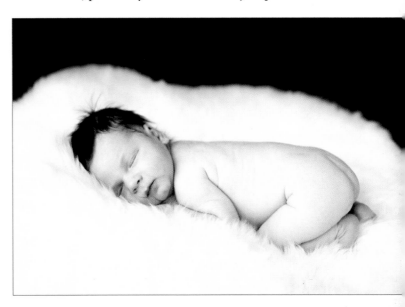

The younger the baby, the easier your session will be—in their first two weeks newborns tend to be very sleepy and flexible enough for some cuddly, curled-up poses. Feeding just before the session will help ensure a sleepy infant.

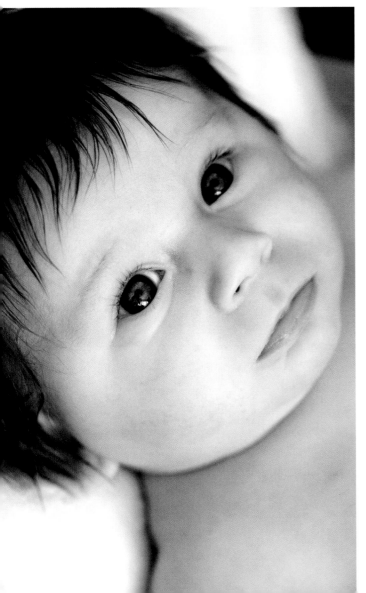

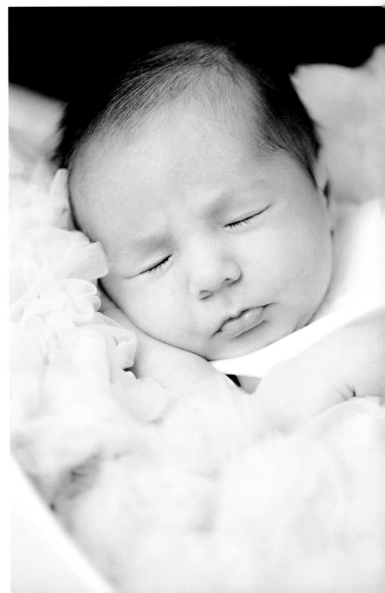

Here you can see the front and back views of one of my newborn setups. The small (but sturdy) folding table has adjustable legs and is set to the lowest setting. On top of the table is a stuffed ottoman with a Boppy pillow. In the center of the Boppy, I place a heating pad set to the lowest setting and a blanket for padding. A larger blanket is mounted partially to hooks on the wall and partially to a light stand. A reflector on a stand is set up to bounce light back into the shadows. (This setup is the result of a collaborative session with two other photographer friends of mine—and it's a perfect example of how beneficial it can be to work in conjunction with fellow artists to build your skills as a photographer.)

ginning a home session. This will induce a sort of "milk coma," which will keep the baby sleepy for a while.

Keeping the newborn warm can be accomplished in many ways, including placing a heating pad (on the lowest setting) under the blankets or other materials that you will be placing the baby on. Turning up the heat in the shooting room or client's home will also keep baby warm. If the adults in the room are too warm, is it probably just about perfect for a newborn baby—especially one who is nude or in a diaper only. Additionally, small vibrating motors for baby soothing chairs can be placed somewhere near the posing area, most babies love gentle vibration. Womb sounds are another wonderful tool for soothing newborn babies. I have a great womb sounds track (downloaded from iTunes) on my iPod that does the trick.

Posing the Newborn

Depending on where your session is taking place, you will have a variety of options for posing the baby. I prefer to photograph newborn sessions in my studio because I have complete control over the lighting and temperature. I also prefer my studio because I have access to more props and do not have to carry everything I might need for the shoot with me. The images to the left show how I set up my natural light shooting room to do a newborn session.

Posing a newborn baby takes careful and steady hands. For safety, I always make sure that an adult is standing right next to the table when I have a baby posed there. I usually recommend that the mother watch from across the room, so as not to awaken the newborn's instinct to nurse. Once the baby is fully asleep, I work through a series of poses as quickly as possible—while I have a willing model. In each pose, a variety of angles can be photographed. This reduces the number of times you need to move the baby into additional poses.

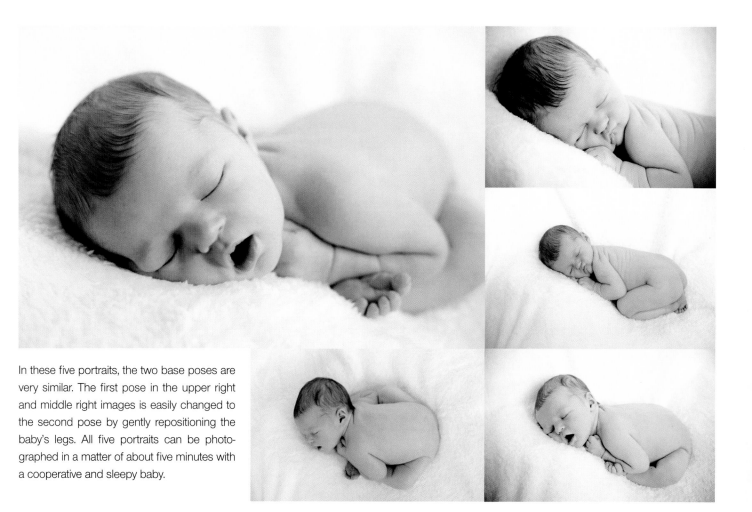

In these five portraits, the two base poses are very similar. The first pose in the upper right and middle right images is easily changed to the second pose by gently repositioning the baby's legs. All five portraits can be photographed in a matter of about five minutes with a cooperative and sleepy baby.

In these six portraits, the baby was posed on her stomach with her arms resting on the higher back ridge of the Boppy pillow. By adjusting her arms in stages, I was able to create a variety of cute poses—ultimately resulting in the middle left pose in which she is balancing her head up on her elbows.

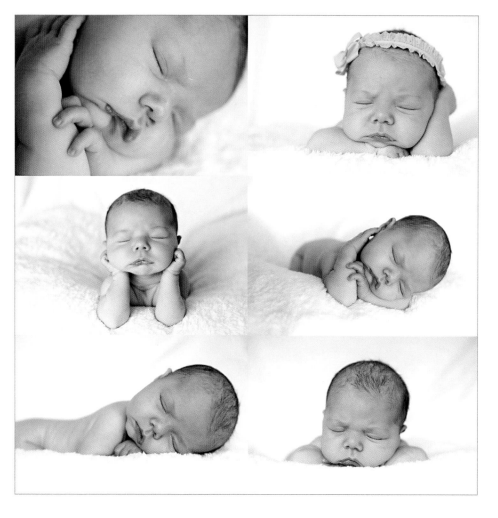

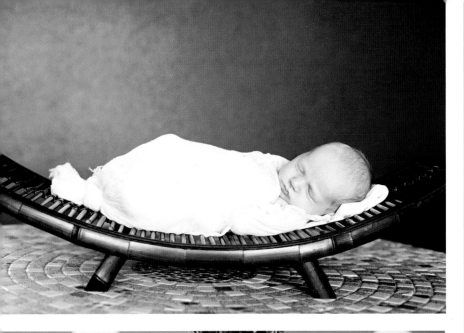

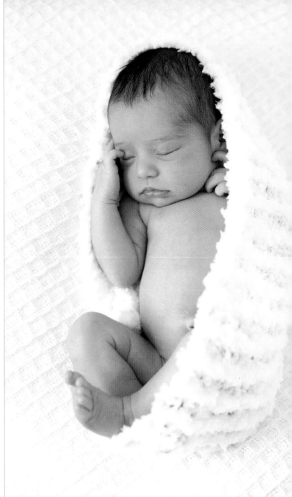

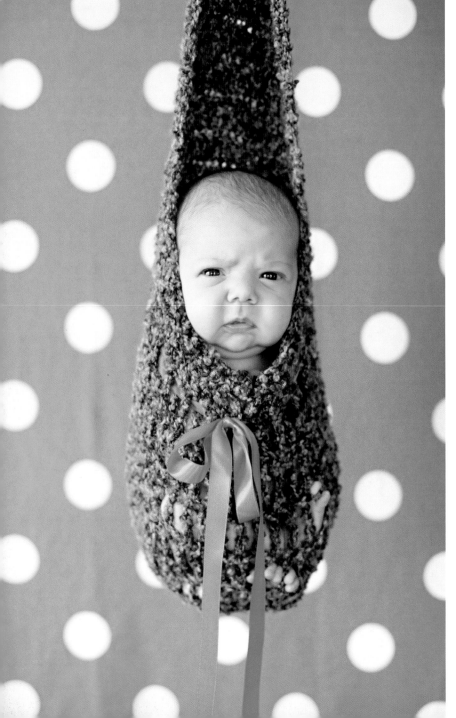

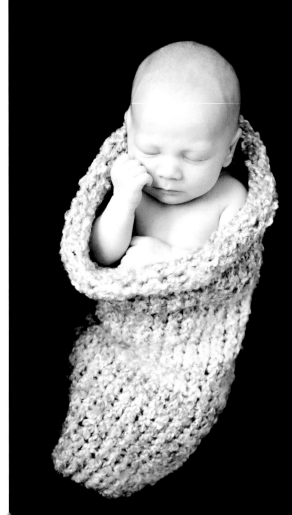

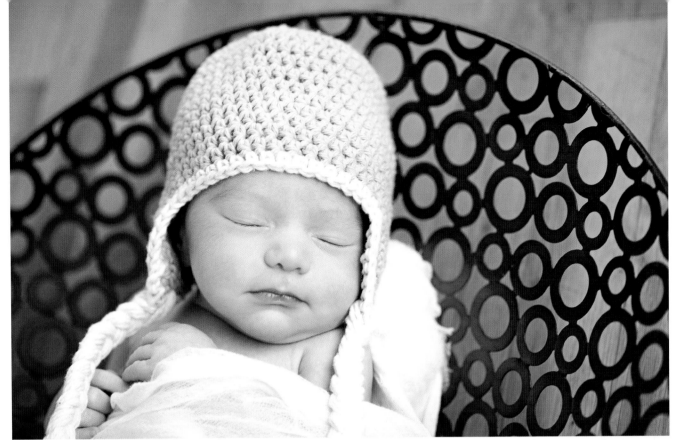

THIS PAGE AND FACING PAGE—Knitted baby cocoons, slings, and hats can be made or purchased at craft fairs and online marketplaces such as www.Etsy.com or www.Ebay.com.

Props, Clothing, Hats, Wraps, Blankets, etc.

My goal with a newborn session is to keep it simple. The more I move the baby during the session the more likely we are to wake him or her up. I will try to accomplish a few poses on the table setup I discussed before, then move to a few different poses utilizing some of my newborn props. I like to use cheesecloth as well as fun, colorful fabrics and the baby's own blankets in the session. Sometimes, Mom and Dad will bring along a special toy or a significant item that they would like in their portraits; I try my very best to accommodate this request.

I frequently peruse online marketplaces like www.Etsy.com looking for cute newborn and baby props and have even made a few for myself. If you are a crafter, consider putting your creative energies to use making some hats or wraps for your photography. I also love to give little knitted items to my clients as gifts for their new baby. They love the special handmade gift and it shows them that I really do care about their new little family.

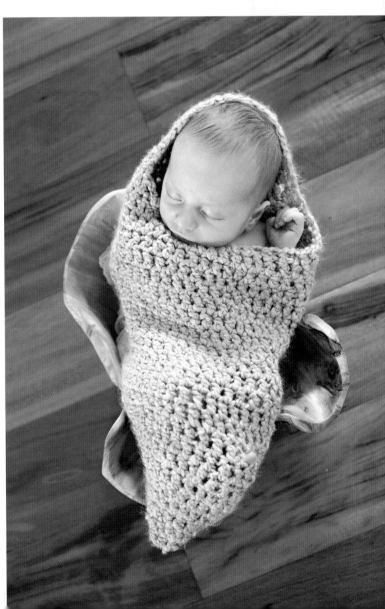

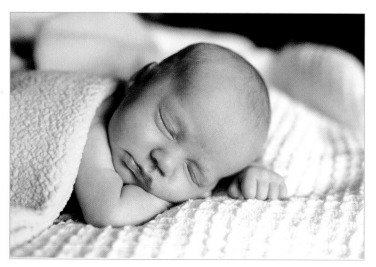

Many newborns have dry or otherwise imperfect skin due to the harsh change from the comfort of the womb to the dryness of the outside world. This image is straight out of the camera and RAW processed with only a slight brightness bump.

I used the Healing Brush to remove some of the dry spots and smooth the area between the baby's eyebrows (sampling from his forehead). You can see, however, that there is still some redness visible in these spots, as well as on his eyelids and around his nose.

Next, I created a Hue/Saturation adjustment layer and selected the Reds channel. I used the eyedropper to sample the redness in the baby's eye and nose areas, then I dragged the Hue, Saturation, and Lightness sliders until the redness was mostly faded.

I then filled the layer mask with black and painted with a soft white brush, set to 15 percent opacity, in the areas where I wanted to remove the redness.

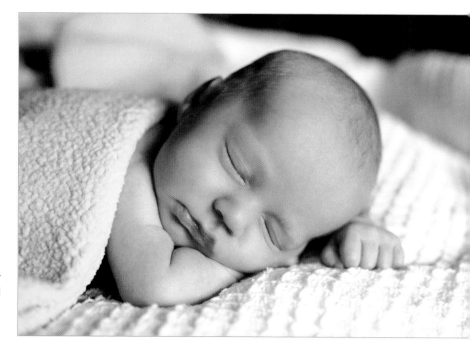

Finally, I chose ProRetouch from Totally Rad Actions, adjusted the effect to my taste, cropped, and sharpened the image.

Special Editing Practices for Newborns

Newborn photography can present some challenges when it comes to editing your images. Babies sometimes have very uneven skin tones, blemishes, or dry and red spots that you will want to retouch. I find that one of the biggest challenges with retouching newborn portraits is removing redness without making the baby's skin look pale and sickly.

I also try to keep the editing simple with regard to color treatments and black & white conversions. Typically, I present the client with a good mix of full-color images and some black & white ones. I find that black & white images, both neutral and brown-toned, are perfect for the simple, innocent nature of newborn photography.

Proofing the Newborn Session

After the newborn session is edited, I pull out a few of my favorites and compose a short slide show set to music. I like to open the proofing session with a slide show for a couple of reasons. First, I find that this visually and emotionally dynamic presentation helps the client to recall the experience of the session—which was hopefully a good one. Second, they will marvel at how much their baby has changed already, and this makes their connection to the images even stronger. Be sure to have tissues on hand for the tears that will inevitably follow the slide show.

Once the slide show has played, I explain to the client the process of choosing their favorites. I begin to show images, first one at a time and then in sets of similar poses. I encourage them to narrow their picks down to roughly twenty or thirty favorites. This is the perfect number for a session book. During the proofing session, I have sample session and first-year books set out, and I refer to them frequently while recommending images that would work well on a page together. I try to close the proofing session with a plan of action for product designs or an order placed.

Products for Maternity and Newborn Portraits

Combining Maternity and Newborn Portraits. As noted in the previous chapter, some of the products I

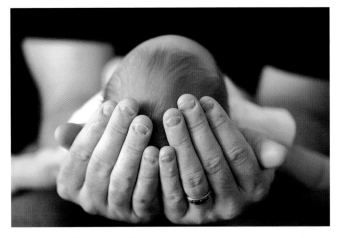

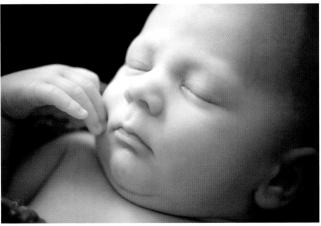

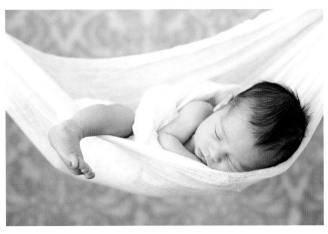

Newborn portraits are perfect for birth-announcement cards, as well as Signature Albums. In albums, consider combining them with images from the new mother's maternity session for a wonderful keepsake of the family's beginning.

offer my clients allow them to combine images from the maternity session and the newborn session.

During the newborn proofing session, I usually bring the maternity portraits up and remind the client of their

When Mom and Dad are oohing and aahing over their newborn's portraits, it's time to remind them about the importance of documenting their child's growth—especially during his or her first year of life.

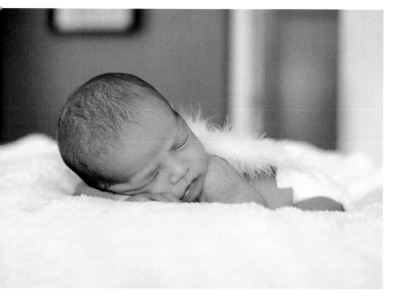

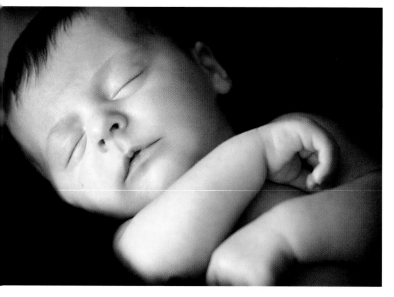

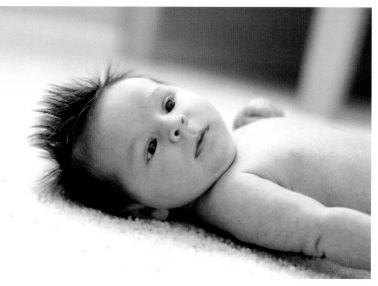

favorites from that session. A perfect product for maternity and newborn images is the Signature Book. I love to offer parents the opportunity to put their journey from couple to family into an album that will be a keepsake for years to come. The Signature Book is a press-printed book consisting of images from both sessions, stories from Mom and Dad about the pregnancy and birth, and other important details about the baby. This book can then be printed on writable pages, so the couple can invite family and friends to write special notes to the baby.

Another fantastic product for maternity and newborn portraits is birth announcement cards. Press-printed cards are offered by most professional labs these days and come in a variety of sizes and paper finishes. A beautiful card with a belly portrait on the front and newborn and family shots on the inside, accompanied by the baby's birth stats, can make a perfect announcement for new parents. These cards can be custom creations or designed using templates. I encourage my clients to choose a design for these cards at the maternity proofing session. Partially designing the card in advance lets me quickly insert the

newborn images after that session and get the cards ordered for the client while the baby is still small.

Creating a Baby Plan

The very best time to cement life-long relationships with your clients is during the baby's first year. Babies grow more in their first year than at any other time in their lives, gaining on average two pounds per month in the first three months and one and a half pounds per month from four to twelve months. They change almost daily.

Most parents are eager to document their baby's milestones and relish the opportunity to have portraits taken every few months. Offering a package that includes three sessions and products tailored to this exciting first year will make your Baby Plan very successful. In addition to the obvious benefit of booking three sessions for the next year (in advance), the Baby Plan also offers you an opportunity to spend time getting to know your clients and forging relationships that will undoubtedly foster future brand loyalty. You are creating an emotional bond that will keep them coming back for annual portraits of their children and family—and also guaranteeing that they will enthusiastically recommend you to all of their friends.

A first-year baby plan can include whatever you feel is appropriate, but I recommend a three-session package, not including the newborn session. These sessions can take place at about three months, six months, and one year—or at specific developmental milestones (this is covered in detail later in this chapter). Each session will have specific goals. To capture the baby's current age and developmental stage, each session should be unique. You may choose to keep all the sessions themed similarly (*i.e.,* using the same or similar backdrops, props, etc.), but I prefer to mix it up and make every session unique.

It is also important to keep close track of your Baby Plan customers, making sure that you call them when it is time to schedule their next appointment—or schedule all the appointments in advance when the package is booked. I will talk a little later about some easy ways to automatically notify your clients when it's time to book their next session.

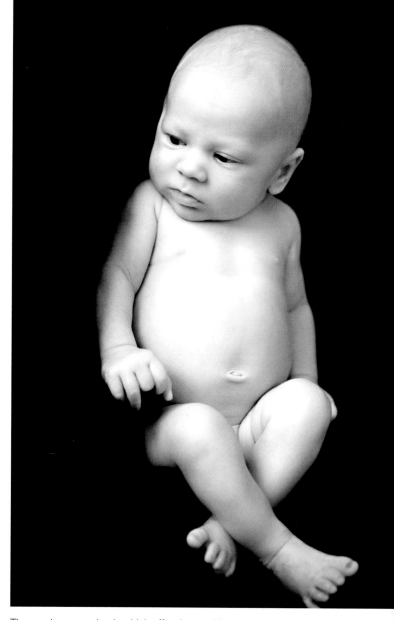

The newborn session is a kick-off to three additional portrait sessions in the first year, each marking a stage in the child's development.

Products for Baby Plans. The key to creating a successful Baby Plan is including products that your clients want. In our current digital age, most clients want to have the printing rights to some or all of their proofs. Including digital files in print and album collections is a great way to encourage larger sales while providing clients with a professional final product. I recommend offering digital files as part of your higher priced packages only, in order to encourage clients to invest in these packages.

Session albums or first-year albums are a very popular product and offer the client the opportunity to display many of their images in the form of a beautiful and cher-

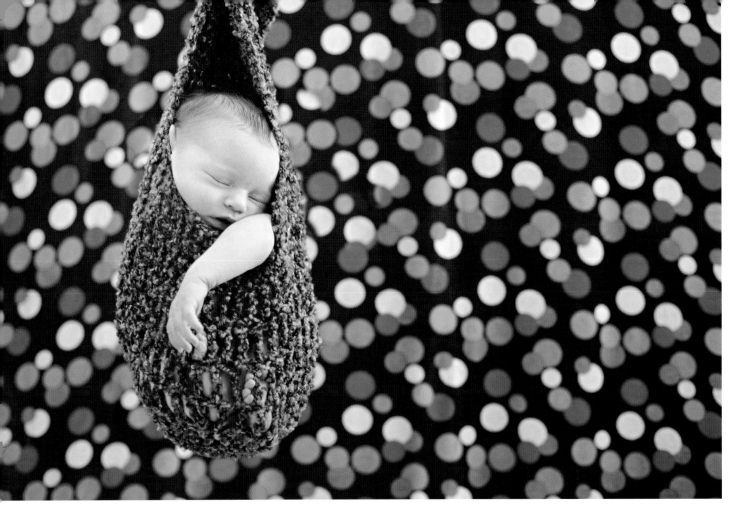

Using ProSelect, I can show clients how images will look in their home at a variety of sizes. When you can so clearly demonstrate how custom art pieces will help them decorate their home, you'll find it easier to sell larger wall prints.

ished keepsake. Most professional photo labs offer press-printed books—and some even offer flush-mount photographic albums. Some wonderful labs that offer these products are Full Color, White House Custom Color, Millers Professional Lab, and Black River Imaging. I have purchased products from all of these labs (as well as others) and have found that I prefer certain products from each lab. I recommend that you try out the services of a few labs, order a few different album and book products, and decide for yourself which company you prefer.

Wall galleries, large mounted prints, and canvas prints also make wonderful Baby Plan products. I encourage my clients to consider using custom portraiture to decorate their homes. During the proofing session, I use the wall gallery templates and room-view options in ProSelect to show clients how beautiful their images can look in their homes. ProSelect's room views feature makes is easy to import an image taken of the client's own home and dis-

play scaled images. This helps them choose the appropriate print sizes for their walls.

Some of the other products I show my clients are custom photo jewelry, press-printed birth announcements, and photo bags. Photo calendars and white-boards also make great gifts for grandparents and can serve as nice thank-you gifts to the client at the end of their Baby Plan sessions.

Some of the labs I mentioned earlier also offer press-printed accordion wallet books. These portable little books are very popular with moms and make a great gift to thank a new mom for her business. Because they are also fantastic word-of-mouth advertising tools, I frequently offer them as ordering incentives or free gifts with purchase.

Pricing Your Baby Plan Collections. Pricing can be very difficult in our industry. The perceived value of a print has been somewhat devalued by the prevalence of

consumer photo labs that offer reprints at very low prices. The important thing to remember when pricing your final products is that there is more that goes into the production cost of an item than just its net price. Some things to consider in your cost of goods sold are the initial purchase or wholesale price, the cost of shipping to you and to your client, the production time, and the packaging. Once you have calculated the total cost of goods sold for a specific item, you will want to decide on a profit margin based on a percentage of markup. There is a fantastic app for the iPhone called Photo Price (www.photopriceapp.com) that can help you calculate appropriate pricing for your finished products.

I recommend including the products and the three session fees at one fixed price. The initial collection price should be slightly discounted, perhaps by reducing the cost of the session fees, to make the initial purchase decision very easy for your client. I also throw in a free newborn session with the Baby Plan—provided the family calls and books a session before the baby is two weeks old. Once they have purchased a first-year collection, you can count on actually seeing them for each of the sessions because they are prepaid. In addition, you may find that, in your client's mind, the prepaid collection is similar to a gift certificate. This often makes them feel more comfortable spending additional money at their proofing and ordering session.

Selling the Baby Plan. In my business, I have found that the Baby Plan basically sells itself. I have priced my collections in a very enticing way, and my clients see what a value it is. I mention my Baby Plan offering in my very first contact with a pregnant mother, or during the consultation conversation. I make sure to detail everything that is included and mention that the session fees are included, making a point to state the regular session fee price for reference. If the creative consultation takes place at my studio, I bring out samples of the products included in the collection for the client to examine. Pay special attention to the products your client expresses the most interest

I recommend including the products and the three session fees at one fixed price.

Because the Baby Plan sessions are prepaid, clients are often more willing to spend additional money at their proofing and ordering session.

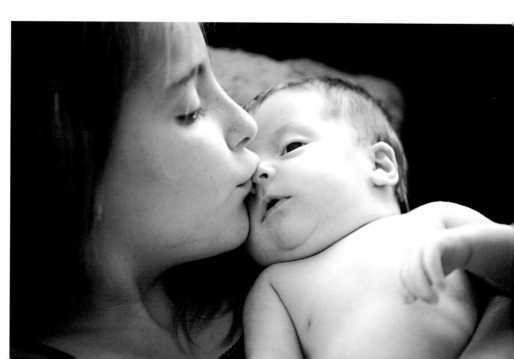

in, making note of this in their customer file. This will help you to guide their purchasing decisions later by presenting their images in the context of their favorite products.

Another important step in selling the Baby Plan is setting the client up on an automatic reminder system for their session due dates, ensuring that they do not forget to book their baby's sessions. This can be accomplished by creating calendar alerts that prompt you (or your studio staff) to send out a reminder postcard. An even more efficient way of keeping up with client session reminders is to utilize an automated online card-sending service, such as Send Out Cards. I find this to be an affordable and very effective way of keeping in contact with my clients. Visit www.SendOutCards.com/storefront/chistiemumm to see what a fantastic tool it can be.

Planning First Year Sessions Based on Milestones

Rather than setting specific ages for first year portraits (*i.e.,* three months, six months, etc.), I find that it is better to plan the sessions around specific milestones. Most babies reach these milestones in the same order and around the same time—but you don't want to schedule a six-month session and find that the baby is not quite able to sit up yet (and therefore needs to be posed in much the same way as for their last session). This does not really show how the baby has changed. For this reason, I schedule each session by the milestone we want the baby to have reached, not just by the age.

Setting up an automated reminder system will help ensure clients don't forget to book their baby's portrait session.

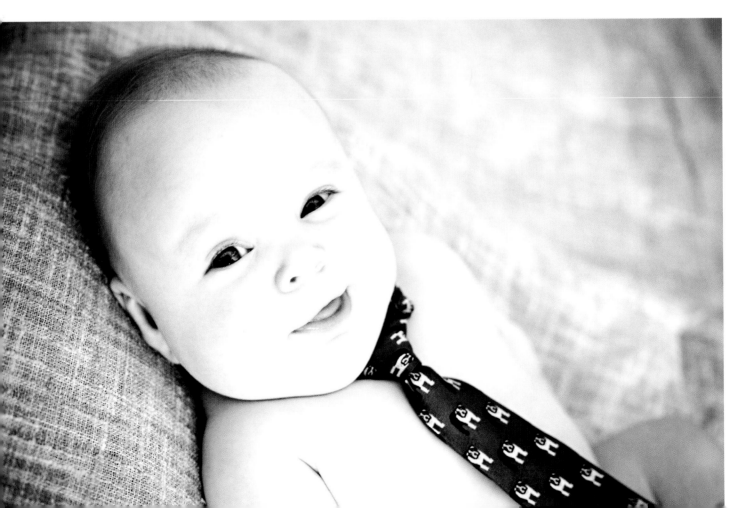

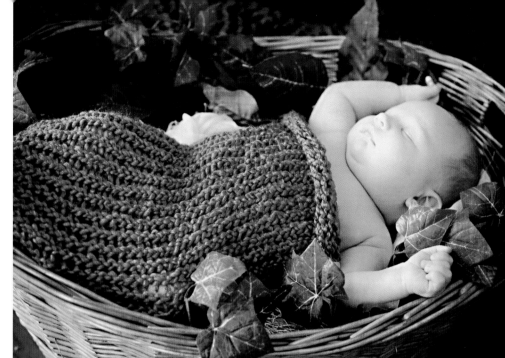

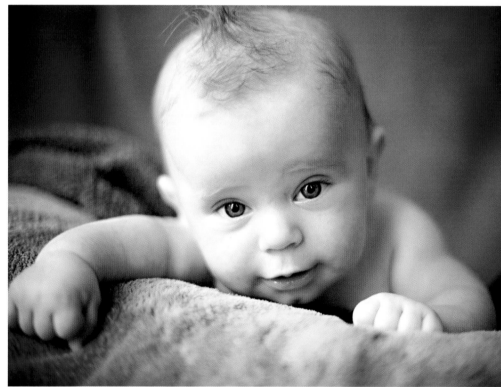

At three to four months, babies will be holding their heads up. Look for smiles, giggles, and hands reaching out for toys.

Three to Four Months: Giggles and Gurgles. At the first session (made at three or four months), the baby should be able to hold his head up when laying on his stomach. Also, look for smiles, giggles, and cooing or gurgling sounds. During this session, you may want to show the baby reaching for toys and possibly gripping some toys. Babies at this developmental stage may be sticking things in their mouths and will respond to tickles and other interactive stimuli. At this age, pose the baby lying on his back or stomach or being held by Mom or Dad.

New milestones are achieved at six to eight months. The baby will now be sitting up and able to support their own weight when held upright.

Six to Eight Months: Sitting and Playing. For their second session, conducted at six- to eight-months of age, the baby should be able to sit up with and without support from their own hands. You will also hear some baby talk ("Dada," "Mama," etc.). At this age, the baby will hold and shake toys as well as respond to peek-a-boo and other gentle play. When held upright, the child will support his weight with his legs; when lying down, he will roll over in both directions. With the child's growing abilities, the posing options become a bit more broad. Try to show the baby sitting without help and standing with help.

Eleven to Twelve Months: Standing and Walking. Finally, at their first-birthday session, the baby should be able to stand with or without support. Babies at this stage may also be walking, so be prepared to chase these little ones down! This can make for some fun images as they walk, fall down, get back up, crawl, and otherwise play actively. At this age, the child will also be able to feed himself, which is great for "smashing my birthday cake" images. Add some balloons to make the birthday portraits even more fun!

At their first-birthday session, kids will be able to stand—and they may be walking, so be prepared to chase them down!

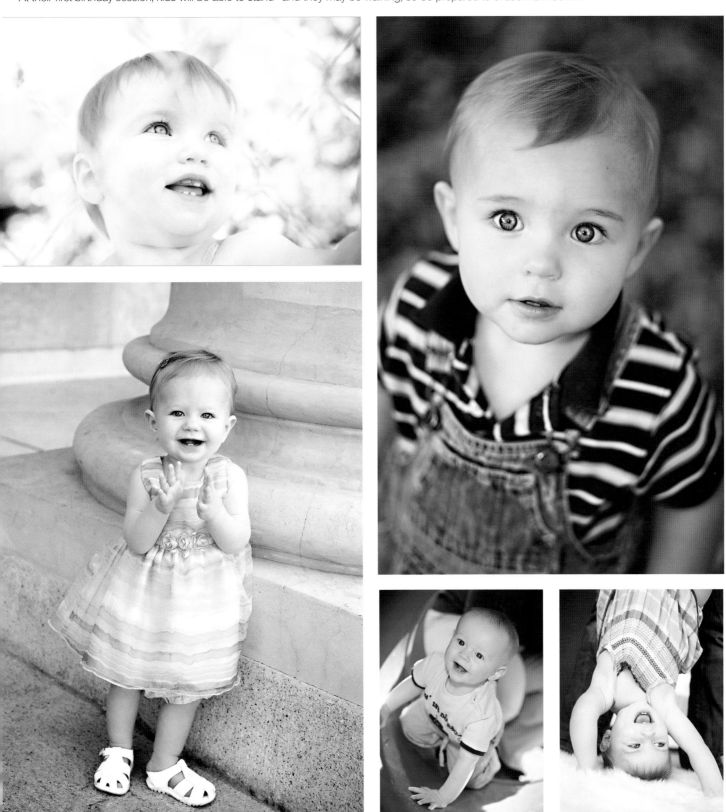

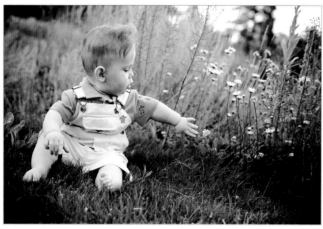

From newborn to toddler, at the end of the Baby Plan sessions, families will have a special document of their child's first year of life—with all the important changes and milestones that have been reached throughout it.

The First Year Album

After the all the Baby Plan sessions have been accomplished, I hold a final proofing and sales session with the client to decide on final uses for their images. The client has most likely been thinking about a first-year album from the beginning. When they come in for their last proofing session, I present a slide show of images from the newborn session through the first birthday session. Be prepared for some major tears as Mom and Dad fondly remember the past year. (I have even been known to get a little misty myself, having formed an attachment to this sweet baby!)

Once the slide show is done, I proof the final session alone, narrowing it down to their favorites just as in all the other proofing sessions. Once the favorites from that session are decided upon, I bring up their favorites from *all* of the sessions and begin talking about putting together a first-year keepsake album. This is a special product that the client will treasure for years and years. In addition to the main first-year album, I also offer them the opportunity to purchase smaller gift books to give to grandparents.

I love looking back on images taken of a child over their first year and remembering how they have changed.

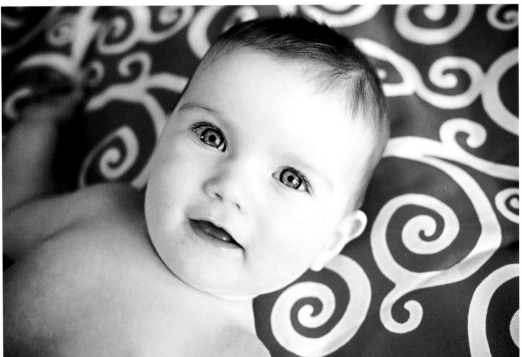

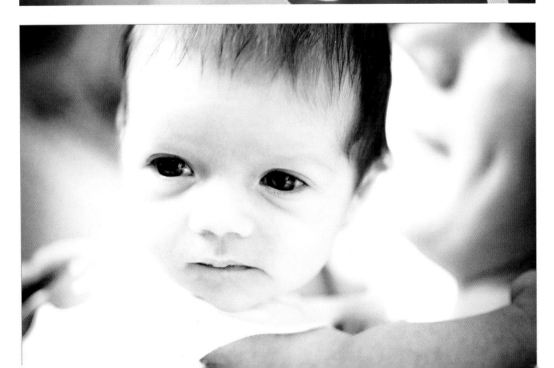

6. "Grow with Me" Sessions

Marketing to Parents

Social Networking Sites. There was a time not too long ago when the main method of marketing to potential portrait clients was direct mailing. This was extremely expensive and, on average, had a relatively low success rate. With the recent advent of social networking sites such as Facebook and Twitter, the cost-effectiveness of marketing to large numbers of potential clients has greatly increased—as has its success rate. No other method of marketing puts your work in front of as many prospective (and current) clients as posting "sneak peeks" on Facebook and tagging the subjects in their portraits. I am amazed at the outpouring of praise and encouragement I get from my clients' friends every time they see new portraits appear.

 Referral Rewards. I maintain that targeted word-of-mouth advertising is the most effective way to reach your market in a way that results in qualified referrals. To build this, I offer special referral rewards to my current clients with small and school-aged children. They receive print credits for every friend they send my way. Many of my clients are happy to refer their friends without any kind of incentive, so when I reward them for something they already do they are doubly thrilled.

The cost-effectiveness of marketing to large numbers of potential clients has greatly increased.

Referral cards created for each client with their kids' images on the front (and your contact information on the back) let parents brag about their kids and drive new clients to your studio.

Encouraging referrals is as easy as providing your clients with small cards, similar to business cards, with their kids' amazing pictures on the front and your contact information on the back. Handing out these cards out lets them brag about their cute kids and tout their "amazing" photographer at the same time.

Distributing Marketing Materials. In addition to social networking and referral rewards, you may also want to target your prime demographic by placing marketing materials in places they frequent with their kids. Places like indoor play parks and jump houses, Mommy and Me centers, gyms that cater to parents by offering childcare, children's clothing boutiques, and toy stores are perfect businesses to approach about displaying your marketing materials. If you have a studio location, you may want to offer these businesses a reciprocal referral by asking them to give you some of their marketing materials to display.

The Every-Year Plan: Birthday Portraits

Many of my clients like to have their children photographed once a year, on or close to their birthdays. I love this plan and it allows me to design a portrait session that celebrates the child. Most children like to be the center of attention and will love having a session that is focused on them individually. As a mother, I see in my own daughter's face how quickly children change and grow. I know how important it is to capture portraits of children that not only show what they looked like at that age but also, and more importantly, reflect what their personalities were like.

A small gift or gourmet cupcake can be presented to the child at the end of their session as a reward for their hard work and to celebrate their birthday. I remember always loving the dentist's office—not because the dentist himself was particularity personable or gentle, but because after my appointment I got to pick a prize out of

Most of my clients have their children photographed every year on or close to their birthdays. Children grow and change quickly, so these sessions are aimed at capturing not just what they look like but what their personality is like each year.

Fun props—or even a messy ice cream cone—can help kids open up during their session.

ing their portraits. They will really open up and show you their true selves.

Engaging Young Children in the Portrait Session

Each child will respond differently to their special session, so I find that it is helpful to begin the session with my camera either put away or slung on my shoulder, rather than immediately sticking it in their faces. I ask parents to give me a little space to get to know their child and help them warm up to me. Some children jump right into the fun of posing and playing with you; others need some time to figure you out and get comfortable. During the "getting-to-know-you" portion of the session, I may ask the child about school, their friends, pets, favorite activities, and cartoon characters. Most children love to talk about their favorite TV show or toy, so this can be a perfect opportunity to begin building a rapport with the child.

Engaging with children is about getting down to their level and listening to them—what they say and what their body language says. Children have a basic need to be appreciated and acknowledged. If you want to bring out a child's true personality and capture that for their parents, you will need to gain their trust and earn their respect. Kids are very intuitive, so be authentic with them. Genuinely listen to them and interact. Letting children know that you care about what they have to say and what they want to do is important if you want to be allowed into their world.

Once the child has warmed up and is ready to begin taking pictures, I start looking for light (if outdoors) and backgrounds that I like and gently lead the child to places I would like to shoot. If we are in a local park, I may ask them if they would like to play on the play structure with me—most kids think it's pretty hilarious when grown-

the prize box. I see no reason why my clients' children cannot be rewarded in the same way.

Some fun ideas for birthday sessions include asking the client to bring a large bunch of balloons and/or a cake for the child to play with. Visiting a local ice cream shop and then allowing the child to make a mess of their face (usually at the end of the session) can be fun. I also like to encourage parents to involve their child in wardrobe choices. Let them bring their favorite dress-up outfit, princess costume, or super-hero cape. Kids love to be given choices, and when they have had a say in the decisions they will be more engaged in the process of shoot-

FACING PAGE—Most kids love to talk about their favorite TV shows or toys, so these topics are good starting points for the "getting to know you" phase of the session. Building their trust and respect helps you capture children's real personalities during the session.

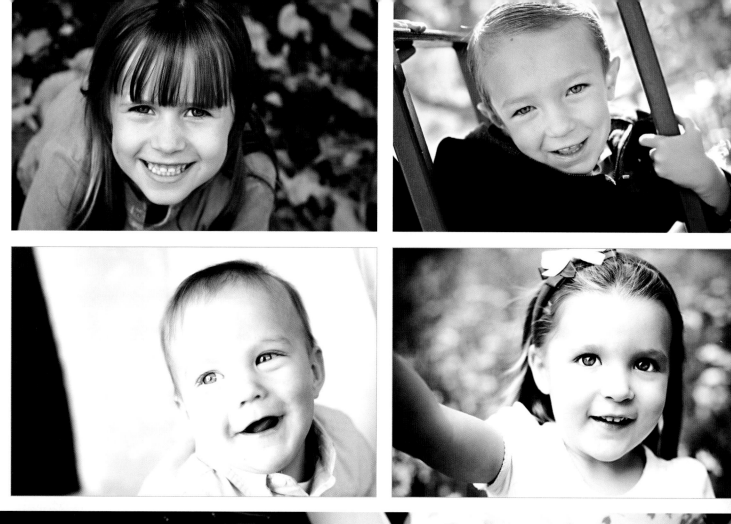
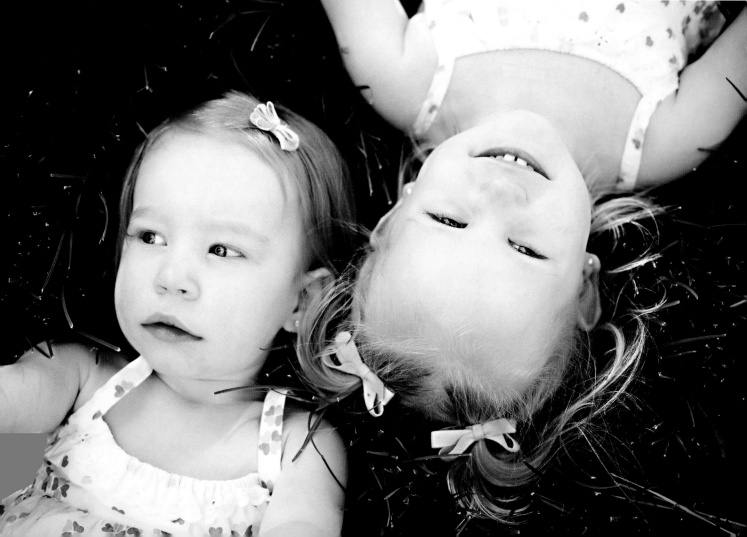

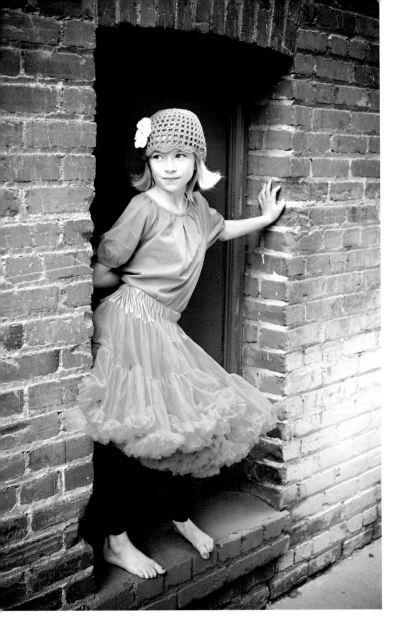

Once the child has warmed up, I start looking for good lighting and background where I'd like photograph them. If the child has their own ideas, be sure to listen to these, too.

the child has been allowed to act silly or goofy—when they are laughing at themselves.

These are just some of my tricks, but you will definitely want to work on developing some tactics of your own. Every child is beautiful and unique. It is our job to coax that special spark from each child, the thing that makes them so special, and capture it in a way that will touch their parents' hearts.

Photographing Siblings and Cousins

Engaging an individual child in the photography process is one thing, but getting two or more small children to cooperate requires special skill. When working with children in groups—whether they are siblings, cousins, or just friends—it is important to engage all of the children at once. For portraits where everyone should be looking at the camera, I like to encourage sing-a-longs, scream-offs, and "who's the scariest monster?" contests. Speaking to the whole group all at once will help to engage their gazes, and hopefully their personalities, all at once.

For more subdued portraits of children (cuddling, talking, hugs and kisses, etc.), I step back and allow them to interact. Suggesting that they make faces or tell each other secrets is a great way to inspire sweet moments—and images that their parents will treasure.

Building a Detailed Childhood Record

I encourage my clients to display their portraits in their homes as art. There is nothing more beautiful than walls covered with expressive and personal portrait images. Because no one has unlimited wall space, however, I also suggest that my clients collect their images in session albums. The is a beautiful way to show off many of the cherished portraits taken in their sessions. If your client chooses an album at every session and continues to bring their child back every year for portraits, in just a few years

ups try to fit onto playground equipment. I frequently ask kids to sing songs with me; "Mary Had a Little Tiger" and "Twinkle, Twinkle Little Hamburger" are almost guaranteed to help coax out natural smiles as the child laughs at the fact that you don't know the words to the song.

Some other tricks for kids are to ask them to play monster and growl at me. When I jump at the "scary" monster, they will normally burst into laughter at having startled me. Another great way to elicit natural smiles is to allow them to make funny faces and goof around. The most genuine smiles and expressions will come just after

FACING PAGE—Photographing one child can be a challenge—but things get even more complex when you start working with groups of kids. In these situations, the key is engaging them together, so speak to the whole group at once.

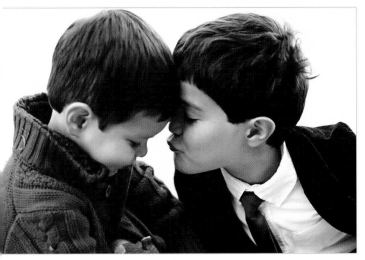
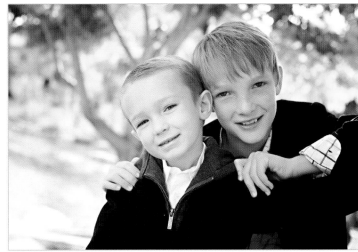

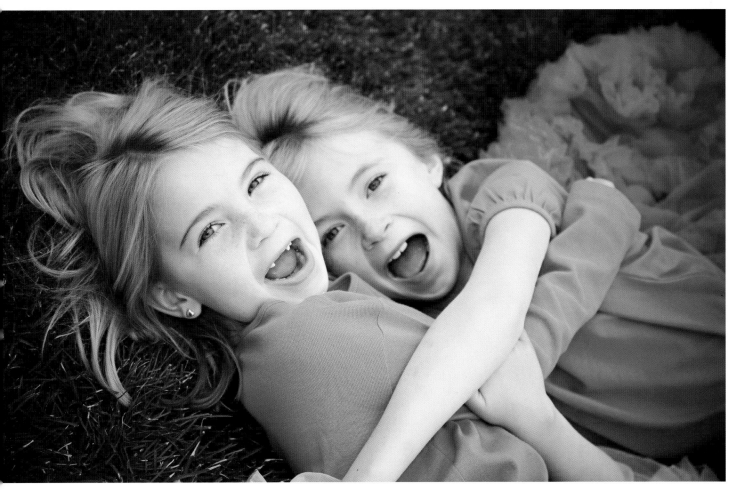

Remind the parents that time passes very quickly—and it's all too easy to let it slip by without documenting special facets of a child's life that they'll want to look back on years later.

they will have a beautiful multi-volume record of their child's growth at their fingertips—tucked away safely on their family's bookshelves.

When working with clients, be sure to talk to them about the opportunity to begin building their child's portrait record through session albums and annual portrait sessions. I share stories with my client about my own little girl and how quickly the time passes. When my daughter was about five years old, she started doing this cute shoulder-shrug when she "fake" smiled. It was adorable—and she did it all the time. I recently went through all my old pictures looking for one of her doing this shrug-smile, but I could not find a single image. It was sad to realize that my own memories are all I have now to remember that cute little quirk.

Photographing Toddlers and Preschoolers

Most people regard toddlers as a difficult age, and with good reason. Toddlers and preschoolers are discovering their independence, testing boundaries, and learning how to interact with the world around them. The best way for them to create a map of their world, their physical and behavioral boundaries, is to literally test those boundaries. This is exactly what they do. Understanding how toddlers think and why they do what they do is important if you want to be able to accurately capture their spirits

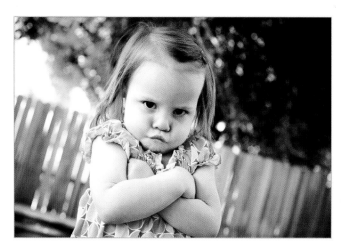

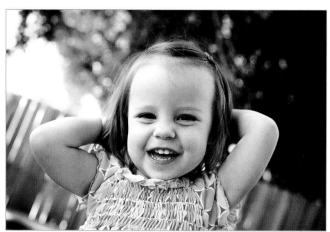

Keep shooting even when the child shows their stubborn or pouty side. Some parents will really love to see this side of their child. As you can see in the second shot, redirecting the child's attention often results in an immediate mood shift. I asked her if I could come up and jump on the trampoline, too—and she responded enthusiastically.

Toddlers can be so much fun—they are really starting to find their personalities and everything is fun and exciting to them.

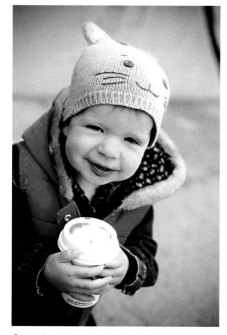

Occasionally, a break is all a little one will need to perk right up. This sweetie just needed a Starbucks hot cocoa and she was ready to go (I can totally relate!). I let kids have all the breaks and snacks they need to keep them happy.

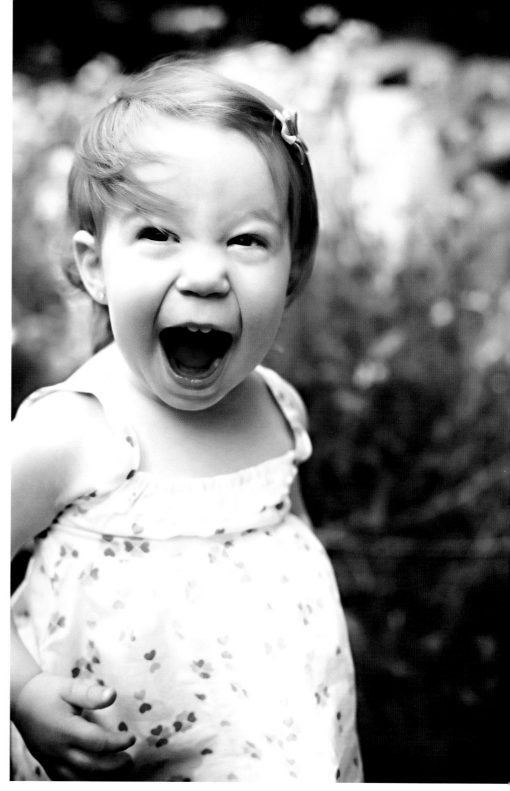

and beauty. I find that outdoor sessions are perfect for toddlers. Giving them some space to explore, and some interesting things to look at, will keep them happy and engaged.

For sessions with active kiddos you will want to get ready to move. These little balls of energy will be all over the place. If you want to capture their sweet faces, you will have to keep up with them. A fast telephoto zoom lens (for instance, a 70–200mm f/2.8) is a great tool for catching some more

candid moments of your little friends. This lens will allow you to create some darling shots as you watch from a bit of a distance while the child explores their surroundings.

School-Aged Kids:
The Most Fun You Will Have!

I could be a little biased because this is the age my child is currently at, but I love school-aged kids. I just love when they get to an age at which they can be reasoned with—and when they love to talk about their lives, friends, and teachers. There is no better way to connect with a kid this age than to ask them about their friends. School-aged kids are very into their friends and beginning to develop

The cookie-cutter portraits kids receive at school don't capture the dynamic and exciting nature of a child's personality. This is a key point to make to parents when talking about the importance of photographing school-aged kids.

Celebrating their sweet (or rockin') sixteenth birthday is exciting for kids—and it can result in some amazing photos.

their social skills. They also tend to be very willing to perform for the camera.

Parents of school-aged kids may not think of it as a priority to have their children's portraits done by a custom photographer because they have school portraits done once or twice a year. This is why I find that these are some of my more difficult clients to market to. The best way to reach these parents seems to be within your own circle of influence. I find that when parents get a chance to share their fun images, their friends and family will want the same type of portraits of their kids. The trick here is showing parents how important it is to capture their children's unique and wonderful personalities. The cookie-cuter portraits that they get from school cannot possibly convey the dynamic and exciting nature of their kids.

Giving kids an opportunity to plan their own wardrobe is so much fun at this age. School-aged kids are beginning to get involved in extracurricular activities—sports, music lessons, etc.—and will usually have some ideas about how to incorporate their hobbies into their session. These sessions are extremely fun and free-flowing, and the images I have had the privilege to capture during these sessions are some of my favorites of all time.

The Sweet Sixteen Session

Is there anything better than turning sixteen? What an exciting age this is. These kids are passing into a new phase of their lives: outward mobility. With the popularity of sweet sixteen parties (or, for boys, rockin' sixteen parties), many parents are now choosing to document this time with portraits, as well. I typically cover the party and hold a separate photography session with the newly driving teenager. Then I create a memory book from the images.

Marketing these types of sessions might actually be more about connecting with the kids than the parents—and this is where Facebook can again come in handy. If there is one thing I know about teenagers, it's that they want whatever their friends have. Posting some amazing images and a dedicated post about the birthday girl or boy will put their images in front of all their friends and guarantee that you receive at least a few referrals. I also make sure to send the birthday girl or boy a card with a coffee or gas card inside to celebrate their independence, which they really appreciate!

7. Family Portraits

Marketing Through Relationship-Building

Social Networking Sites. Keeping in contact with your clients is a very important part of relationship marketing. The relationship must grow in order for it to remain healthy. Stagnant business relationships, just like unmaintained friendships, will wither and die over time. One fantastic way to maintain your relationships with your clients is to have both a business and a personal profile on Facebook. I recommend that all my clients join my fan page as well as add me (personally) as a friend. When clients add me as a friend on Facebook, I am also able to tag them in pictures I post to my business page. This places their pictures on the home pages of all of their friends as well as on the pages of my business's fans. I cannot think of a better way to get my work in front of hundreds of people at once—especially not for this price: free!

Greeting Cards. Another fantastic method of keeping up with clients is to create a birthday and anniversary card list. I use Send Out Cards for this, because it is a simple and affordable service. When creating each client's file, I enter them into my address book and set up reminders that will prompt me to send them cards at significant times. I even have the option to send gifts. I take an hour or two each month to send out a card to every client who has a birthday that month. I can write a personal message and even use a personalized handwriting font and custom signature. I love getting a call from a client

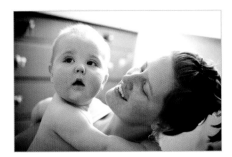

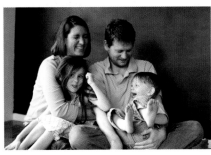

When clients add me as a friend on Facebook, I can tag them in pictures I post to my business page—putting the tagged photos (and my business information!) on the home pages of all their friends.

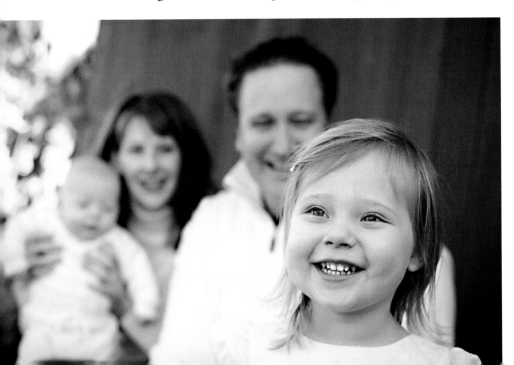

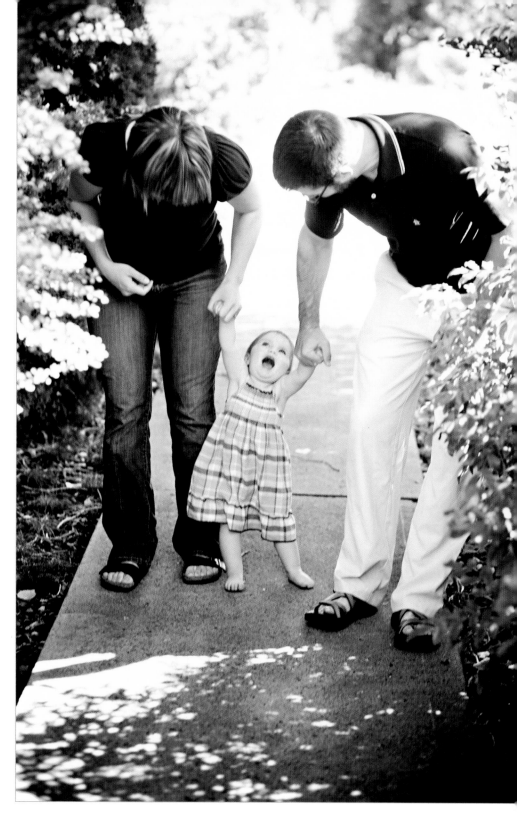

saying how much they loved the card I sent and they are so thankful that I remembered.

Newsletters. Newsletters, either digital or in print, are another wonderful way (although one-sided) to keep in contact with your clients. Do not be afraid to get a little personal; write about your life and share what is going on with you and your family. Studies have shown that when people identify personally with the face or CEO of a corporation they are more likely to do business with that company. The same thing that applies to large corporations also applies to small businesses—but even more so. Small business are largely run by their owners, so when a customer connects with that owner and feels a connection with them, they will be far more likely to frequent the business.

For example, my family and I used to frequent a local BBQ restaurant that was about two minutes from our house. We loved their food, but more than that we loved the owners—a fun and personable couple who poured everything into their business. The woman who owned the place would make special meals for our young daughter and even made her a birthday cake in her favorite flavor and colors. We ate there half a dozen times a month. When the restaurant suffered some unfortunate losses due to the slow economy and sadly closed, we were even invited to their farewell party. Though it has been almost three years now since they closed, we still commiserate about how much we miss them. We compare every other restaurant we eat at to our beloved favorite. That kind of loyalty comes from offering a stellar product and then backing it up with a truly personal experience.

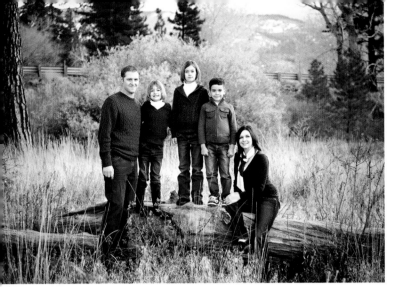

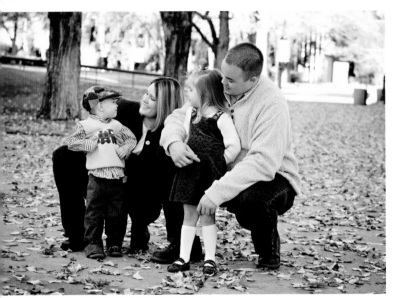

Encouraging my clients to come back for annual family portraits—and to use portraits as gifts for friends and family—has been important in building my business.

If you want to create customer evangelists, here is the secret: Produce amazing work, then wrap it up in the experience and personal attention only *you* can offer. I do not claim, by any stretch of the imagination, to be the best photographer in the world. I am well aware of the many, many amazing and talented artists in this industry—and even in my own local market. What I will claim, however, is that I am the only person who can offer me. *My* attention and *my* affection are only available through *my* studio. The only commodity that cannot be replicated is you. So be truly, authentically yourself. Open up your heart and let your clients in. You will be amazed at how your business will grow.

Annual Family Portraits

Recording the subtle changes that take place in a family from year to year is a special and privileged role that I relish with my frequent clients. There are families that I see every year whose children have become very precious to me. I love that moment when I meet up with a family I haven't seen in months (or even a year) and their kids run up and give me a hug. I gladly wear the badge of "Christie the picture lady" and my heart is warmed by these relationships.

Annual family portraits should be a part of every family's routine. Encouraging my clients to return year after year to update their family portrait and use portraits as gifts for friends and family has been important in building my business. I have even had grandparents contact me to say how special the portraits they receive every year from their families are.

I run specials every fall to encourage families to book early and purchase holiday cards, which are also amazing word-of-mouth marketing pieces. I have gone into clients' homes and been able to pick out multiple portraits that I created mounted to their refrigerators in the form of holiday cards from their friends.

Over the years, building relationships with my clients and their circle of friends and family has also been personally beneficial. Many of my clients have become friends; there is no more touching gesture than when I am invited to a birthday party, picnic, or baby shower for a client-turned-friend.

Day-in-the-Life Sessions

Another wonderful concept in portraiture is the "day in the life" session. This type of session will typically take longer than a normal session and will usually be held, at least in part, in the client's home. I have a dear client who moved away—to another state, in fact—who actually flew me to their new home to photograph their family.

FACING PAGE—Day-in-the-Life sessions allow you to document a family as they really live—from making breakfast together to taking a bike ride around the park.

These sessions are fun and a real opportunity to get to know your clients. I would love to see every family I work with do at least one of these sessions at some point when their children are still young. The session consists of capturing the family in their normal interactions—making

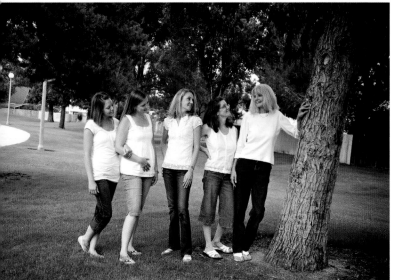

lunch, riding bikes, going to the park, having ice cream, etc. The key to success is gaining the trust of all involved, which is why I typically market these sessions to families I have already worked with at least once.

Begin the session by asking the kids to show you their rooms. Children love to show off their toys, artwork, and personal space. Prepare the family by informing them that you will potentially shoot in every room of the house. Ask the parents to plan some fun and characteristic activities for the day. This will allow you to document the family together having fun and interacting. Shooting a bit of video, if your camera has the ability to do so, can add a fun and personal aspect to the session; it can be included on a keepsake DVD for the family.

A family storybook makes a perfect final product for these types of sessions. Ask Mom and Dad to write something special about each child, and about each other, to include in the book. Also consider including excerpts from the children's favorite books or lyrics to their favorite songs. Photograph some of their artwork to make this a truly special keepsake. Producing these as digital flushmount or press-printed books will allow you to offer the family multiple copies to give as gifts. Grandparents especially love them.

Photographing Large, Extended, and Multi-Generational Family Portraits

Large families can be a challenge to photograph, especially when there are many small children involved. The trick to expertly executing these sessions is to keep things simple and make it quick. When consulting with your client about a large family session, it is important to understand how many members there will be and what ages they are. A group of five nuclear families with grandparents and seven or eight small children can become a huge fiasco very quickly, so you must be comfortable taking charge of the situation right from the start.

When photographing large family groups, the key is to keep it quick and simple.

White shirts and jeans help this big family look like a cohesive group—and help keep the focus on the faces and expressions. The finished look is clean and appealing.

Wardrobe. Wardrobe considerations are critical with large families. Uncoordinated outfits can create a very distracting portrait, so I recommend that large families choose either a color theme or a tonal theme. Some great ideas are to put each nuclear family in a different color while keeping the whole unit within a similar tonal range (*i.e.,* all jewel tones, all pastels, all neutrals, etc.). Another look that many clients like is the "all in white" look. Though photographing a large group of people in white and denim or white and khaki can be tricky, the finished look is very clean and appealing.

Posing. When posing large families, I have a couple of different tactics. One approach is to place the oldest members (usually the grandparents) in the center of the group, then build the larger group out from there by placing each nuclear family into position one at a time, trying to keep the overall group balanced. Another method is to spread the family out in a linear pose, all holding hands. This makes a very fun and aesthetically pleasing arrangement.

Smaller Groups. During the large family session you will want to offer each smaller family an opportunity to have their own portrait taken. You may also want to take smaller-group shots: the grandparents with the grandkids; all the kids; all the adults; and the core family (usually the grandparents and their kids). Don't forget to capture some candid shots and the kids alone. If the large family session is run properly, it can result in many large sales; each family will want copies of all the poses.

Posing for Families

Most of my clients are looking for a good mix of casually posed and candid shots from their sessions. I begin by looking for the best light in any given location, then suggest posing that will allow the family to interact and reveal their personalities. Traditional posing rules for groups favor a balanced arrangement. I find that a few general rules serve me well.

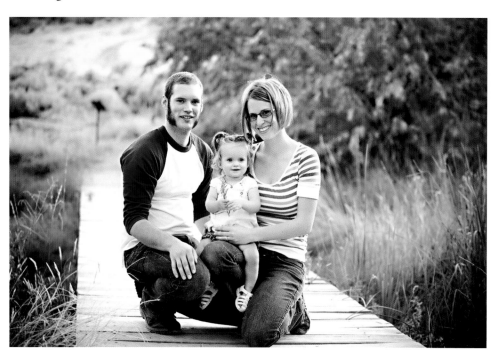

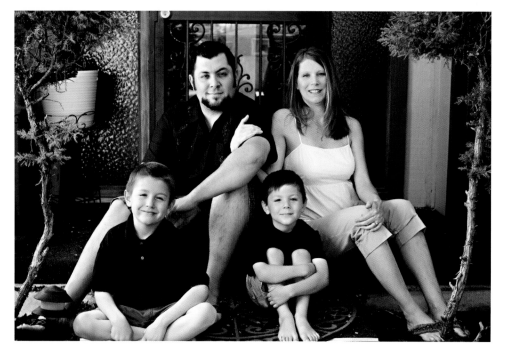

The Triangle Rule. Posing families to create triangle patterns that are somewhat equidistant in spacing will feel balanced and keep the viewer's eyes moving from subject to subject. It is human nature to be drawn to triangles, a shape that is repeated in nature over and over again. When you are looking at a family pose, be wary of groupings that place one subject out of balance or somehow "out" of the group. There are, of course, exceptions to this rule.

In certain cases, an offset subject can draw attention to that person in an interesting and narrative way. Typically speaking, however, you will want to be able to draw many different triangles with the placement of the faces in your composition.

The Linear Rule. Placing families in linear poses is a great way to draw the eye through the portrait in a fluid way. Try to use leading lines with these poses if at all possible; this will create a sense of flow in the image. Linear poses make fantastic panoramic or wide prints and can be placed on walls where vertical space is limited.

The "Groups" Rule. Posing families in smaller groups can make for fun, unique portraits. Whether you place the children separately from the parents or divide the boys and the girls, the "groups" rule can create poses that are fun and full of

TOP—Families of three are very easy to pose as they will naturally fall into a triangle pattern. **BOTTOM**—With families that have an even number of members, be careful not to create a perfect square. With a family of four, a lopsided rectangle or parallelogram created from multiple triangles produces an intriguing yet balanced pose.

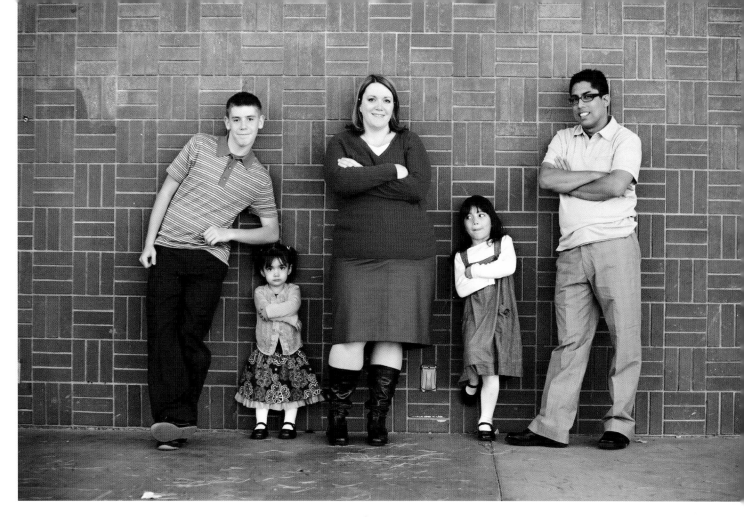

TOP—Allowing this family to settle into their own personalities within the pose has made for a truly authentic portrayal of their family dynamic. I love how the littlest one is showing her stubbornness, the middle child is sneaking a peek at what everyone else is doing, and the eldest is picking on the little one. This image makes me smile every time I look at it and it ended up being their favorite from the session. **CENTER**—In this family portrait, the mother and father are positioned as the center of the group and their boys move out from them. The leading lines from the parents in the center to the outside children make the viewer's eyes move back and forth through the image as they scan each face one at a time. **BOTTOM**—Here the "U" shape of the grouping has the eye moving from the father, to the daughter, to the son, and up to the mother—and back again.

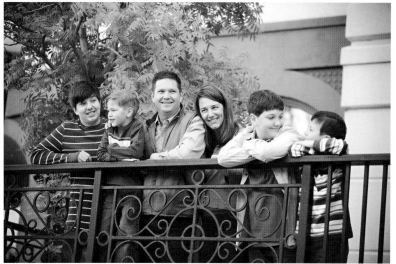

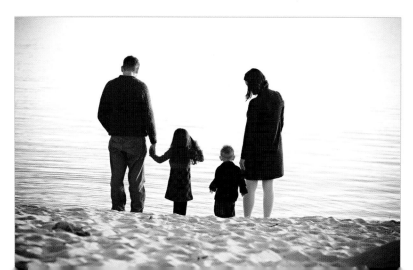

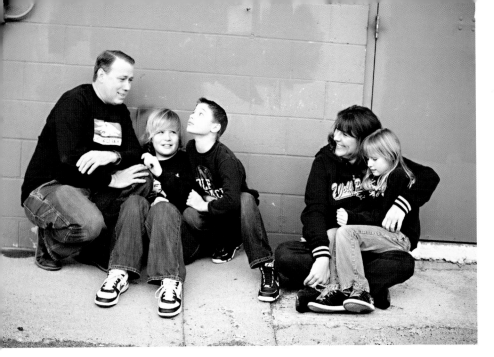

TOP—This family portrait uses the "groups" rule, separating the boys from the girls to juxtapose their personalities. I love how the family clown in the middle is vying for Dad's attention. Mom looks on, obviously amused at his antics. **CENTER**—The two groups are on different planes, rendering the parents and baby out of focus while the two big girls play it up for the camera in front. **BOTTOM**—In this pose, the parents are placed on a different plane from the children—far enough out of focus that they seem to fade into the background; even their facial expressions are not distinguishable. You will also notice that the children are posed in a way that follows the linear rule.

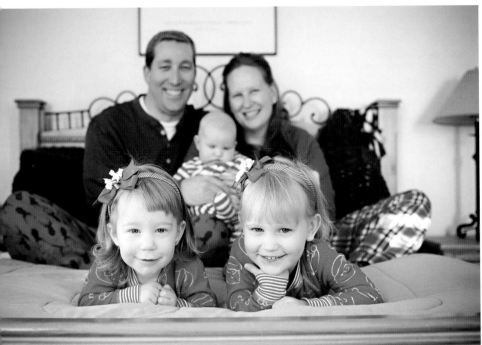

life. Encourage the smaller groups to follow either the triangle or linear rule; this will make each of the smaller groups feel more cohesive and balanced. One thing to consider with this rule is focus. When the groups are placed on different planes, you will have to make a decision about focal points and whether or not you want all of the subjects in focus.

The Lifestyle Portrait. The last posing rule I will talk about is the "unposed" rule. I try to capture a good mix of loosely posed images and candid shots in each session. When shooting in this fashion, you will be an observer and simply allow the family to interact and move around the shooting location. Walking, climbing, and otherwise being active is the name of the game here. Encourage your clients to play, explore, and try to forget that you are there at all. I will usually put on my long zoom lens for this portion of the session and shoot stealthily from a distance.

The philosophy of lifestyle portraiture is to capture the subjects in their natural environment. Interactions between family members are some of the

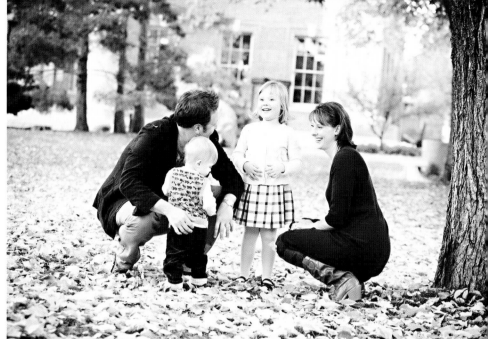

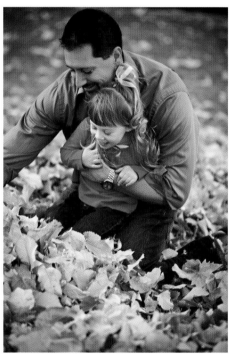

Allowing families to have some fun, unstructured play time during their session is a great way to capture images that convey the true nature of your clients' relationships.

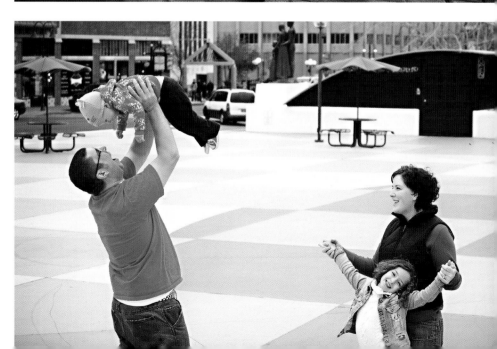

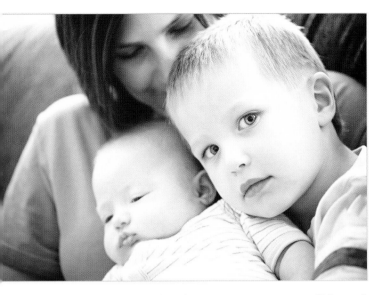

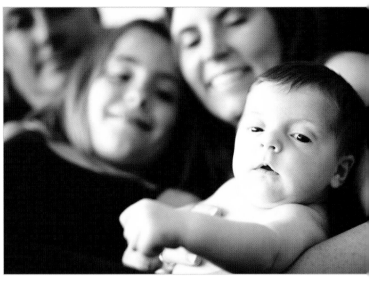

most honest and authentic moments you will have the pleasure of capturing in your images. In fact, some of the most evocative and moving images you create will be those that are captured in moments when your direction is not present at all. I strive to be an observer of human nature and relationships. If you open your eyes to the world around you and allow the beauty of creation to wash over you in the present, your work will become a true representation of your subjects. Living life in the moment and appreciating your clients for who they are, and what they mean to each other, is paramount in this business.

Don't be afraid to frame your subjects very tightly and even crop off portions of heads or faces. These shots create a sense of intimacy and can make for some beautiful, moving portraits.

Special Location Sessions: Portrait Excursions

Another specialized offering you may want to consider is the portrait excursion. I am fortunate to live in a central location on the west coast of the United States. Within driving distance from my home, I have access to beautiful lakes, mountains, interesting deserts, the ocean, and so forth. Selecting a few special locations each year to host portrait excursions can be a wonderful way to offer your clients something truly unique. Portrait excursions can be offered in a similar fashion as the portrait party or as mini-session events, for

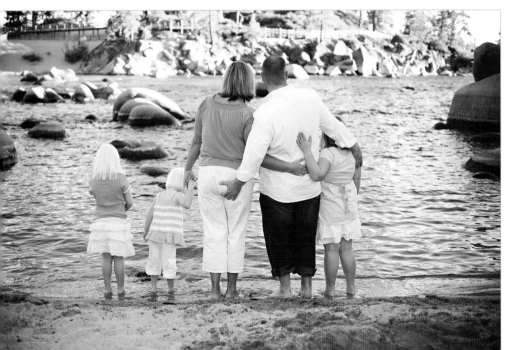

You never know when your subjects will choose to do something funny and surprising. Allowing your subjects the freedom to express their affection for one another in their own way can result in some truly authentic—if not hilarious—images!

which you make multiple appointments available to your clients on a given day. They can also be offered to individual families as a private custom session.

Locations to consider might be any local beaches, mountain vistas, amusement parks, and tourist attractions. Get creative with these locations—reach out into the areas within your own region and even beyond. Sessions can also be planned for more distant locations. In fact, offering your clients the ability to bring their photographer along on a tropical vacation, ski weekend, or other special family trip is a fantastic way to build travel into your business. What better way to commemorate a special family event or vacation than with beautiful photography!

Products for Families

Once you have created images that capture the true nature of your subjects, you will want to offer your clients products that allow them to share these images with those they love. These products will fall into one of the following categories: display, gift, or keepsake. Display products are those items that your clients will place on the walls of their homes; large wall prints and groupings fall into this category. Gift items are those that they will share with their friends and family; such items include smaller prints, cards, jewelry

Locations to consider for family portraits could include anything from parks and beaches to amusement parks.

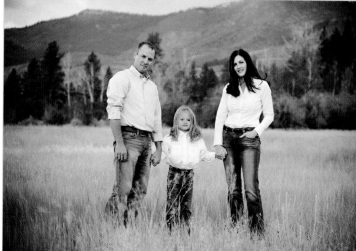

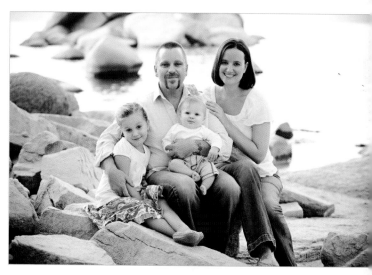

Presenting the family portraits as a slide show is an excellent way to bring fun memories of the session rushing back.

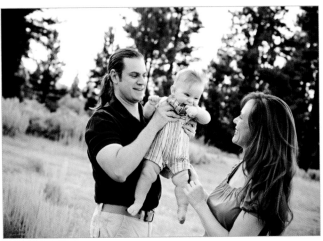

items, and smaller books. Keepsake items are those that the client will treasure and refer back to in order to evoke memories and emotions in the future; these include albums and books, digital files, and media pieces (such as slide shows).

Offering a wide array of specialized products to your clients will ensure that your images are treasured for years to come. One thing to keep in mind when presenting images to your clients is that they will not usually know all of the fantastic ways their images can be used. Showing is selling, so make sure to carry samples of the products you offer—after all, if your clients don't know about the fabulous products you carry, they certainly won't purchase them. At the very least, a product catalog or showcase is a great way to present options to your clients. Take some time to research the products on the market and compose a sell sheet or catalog for clients to view in preparation for their proofing session.

Proofing and Selling the Family Session

After the images are captured, edited, and ready for viewing, you will want to have a plan in place for running your proofing session. As mentioned earlier in this book, I like to show my clients a slide show of their images as the opener to their proofing session. The slide show is an excellent way to bring the memories of the session rush-

ing back and connect your clients to their images in an intensely emotional way.

You should have an idea, at this point, of what your clients expect to use their images for. They may have mentioned that they plan to purchase a large image to place over their fireplace, or that they want to order holiday cards to send out to friends and family. If you have conducted a creative consultation with your client in advance of their session, you may also have a good idea of what kind of images they will want to use for their display, gift, and keepsake items. As the artist, you should make recommendations on images for specific uses.

Your sales script might go something like this: "Mrs. Johnson, we discussed your desire to have a gallery wall created in your living room, displaying images of each of your kids and a family portrait. I have selected some images that I believe will look beautiful displayed together on your walls and would like to show you how this would look in your home." You can then utilize a wall gallery template, such as the one offered by the Life Art Design Shoppe, to put together a layout for their wall display.

The same approach can apply to the creation of session albums and greeting cards. Guiding your clients' purchasing decisions, based on the preferences you have established in your previous conversations with them, will ensure that they walk away from the sales session feeling good about their purchases. When your client is happy with the purchasing decisions they have made with you, they are more likely to rave about your work to all of their friends.

Part of being a good friend to someone is paying attention to their preferences and taking them into consideration. When I shop for a gift for a close friend or family member, I think about who they are and what they like. I would never purchase a brightly colored purse for a friend who dislikes wearing bright colors. In the same way, I would not recommend a large wall portrait to a client who does not have much wall space in their home.

Your ability to help clients choose products that suit their tastes will be a major factor in their level of satisfaction with your services.

This is where building a foundational relationship with your clients will be crucial to the level of satisfaction they will ultimately have with your services.

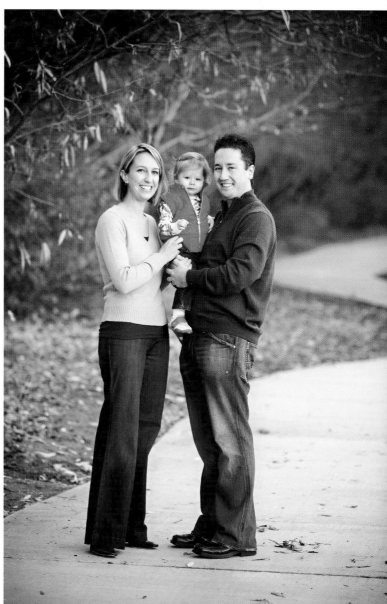

8. The Senior Portrait

Marketing to High School Seniors

High school senior portrait sessions can be fun and very creative. One thing I particularly enjoy about working with these young adults is the opportunity to begin a relationship with someone who is just entering the real world—someone who is full of hope for the future and just beginning to imagine the possibilities of their own life. It can be very energizing and inspiring.

When photographing senior portrait sessions, you will be marketing to two demographics: the parents and the students. Most of the time, these two will have very different ideas about what they want. It is important to deli-

Senior portraits have to please both the senior and the parent who is paying for the session.

When marketing senior portrait services, you'll want to show beautiful, moving images in conjunction with attractive pricing.

cately and expertly tread the line between the parents' and the child's expectations during the senior session to make sure everyone is happy in the end.

Your marketing efforts to the parents of high school seniors should focus on showing beautiful and moving images of students, while packaging sessions and products in a way that is financially attractive. One way to reach the parents of students is to contact high school booster clubs and other parent organizations. Parents who are highly active in their students' schools are wonderful clients to have. These parents are crazy about their kids and will be very interested in your services if you can convey your delight in capturing their young adult child as a unique and beautiful person. Mothers will be especially receptive to the opportunity to show off their images to other parents in their circle of influence, so offering them session and brag books will do wonders to encourage referrals.

When marketing to students, you focus your efforts on showing images that highlight the subject's individuality. High school seniors are eager to express themselves and will love to show off images that capture who they really are. These kids are best contacted through their social networks, so sharing senior portraits images on Facebook and blogs will do wonders for your marketing efforts.

Images that highlight the subject's individuality will appeal to high-school seniors.

The Senior Rep: Your Marketing Secret Weapon

The idea of recruiting seniors from all of your city's schools to act as representatives of your studio is not a new concept, but I have taken a new spin on this idea. Rather than limiting each school to only a few students, who may or may not have a broad group of friends within the upcoming senior class, consider

allowing *every* student to be a rep. I offer every senior client the opportunity to have their own customized rep cards, similar to business cards, which contain their contact information on the front and my web address (along with a special offer) on the back. I start all the students off with fifty of these cards, which I have printed at my professional lab at a very reasonable price. If they run out, I will gladly order more for them.

Parents love the senior rep card. It saves them money on wallet-size prints and allows them to spend the majority of their budget on larger prints and announcements. Students love the cards because they can give their contact info out to their classmates before leaving for college.

In addition to the rep cards, I also reward my senior clients for the referrals they send me. Each friend they send who books their senior portraits with me earns them ten points. They can then spend those points on items they love, such as iTunes and Starbucks gift cards—

or save them up for more ambitious rewards, such as iPods and digital cameras. The rewards system is a perfect way to encourage students to share their pictures and talk about my studio. The cost of the rewards (just $10 per referred senior) is pulled right off the top of the friend's package and placed in an account used to purchase the items used as the rewards. At just $10 per senior client, I find that my money is very well spent.

Making Mom and Child Happy

Mothers and their teenagers will have very different ideas about senior portraits. When it comes to wardrobe considerations and location planning, I attempt to bridge the gap between mother and child by suggesting solutions that will please both simultaneously. If you want to be really successful with senior portraits, this balance is imperative. You do not want to limit yourself by becoming known as the "boring" senior photographer to the kids

I offer every senior their own customized senior rep cards—and provide compelling incentives when they use them to refer friends back to my studio.

LEFT—Many parents desire a traditional posed portrait of their child. **RIGHT—**The students will want something that shows their individuality.

A delicate balance between the parents' and the child's visions for the session will make sure both parties are happy with the results—ensuring high sales and positive word of mouth.

or the "off-the-wall" photographer to the parents. This philosophy of striking a balance has served me well in my senior portrait business and results in my clients referring all their friends to me year after year. I know it will benefit you as well.

Creative Senior Sessions

Clothing Selection. When planning the senior session, encourage the creative use of wardrobe, locations, and props to create something highly customized. I recommend that my senior clients bring along at least four different looks. I like to see a good mix of fun, casual outfits and more dressed-up, what I like to call "date night," attire. Some clients choose to go with only one or two outfits, and this is fine too; ultimately, you want them to be comfortable with what they are wearing.

Props. Props for senior sessions can be anything that the subject feels connected to—from sports gear, to personal memorabilia, even a vehicle. I like to see kids bring in a variety of items that help portray who they are. I even encourage them to bring along pets and boyfriends or girlfriends, which can add a special element to the images. I would caution you, however, to use props only to accent certain poses, not as the focus of every shot.

Nothing is more generic than a series of portraits of a senior holding a different item in each pose. Ultimately, the session needs to be about the student. Your job as a photographer is to capture the essence of who they are in this moment, at the end of childhood and on the cusp of adulthood.

From sports gear to beloved family pets, props help personalize the look of a senior's portraits.

RIGHT AND FACING PAGE—Rail yards, parking garages, urban murals, churches lit up at night, and storefronts are visually interesting locations for senior sessions. Furniture in an open field can be a fun setting for seniors. The bridge in the bottom right photograph is a favorite shooting location of mine. I just love the juxtaposition of steel bridge against the natural beauty behind it.

Selling in advance of the session helps me to shoot with an awareness of what types of final products the client will be receiving.

Locations for Senior Portraits

Senior sessions can bring out the creative side in the photographer and subject alike. I love meeting with a student and talking about their future plans, likes, hobbies, etc., then putting together a plan to create images of this unique and beautiful young person. Many seniors have an idea of where they would like their session to take place. I can usually place a child into two broad categories for their theme: urban or natural. From there, we can pick a suitable location or series of locations. Urban locations offer a wide variety of options—from graffiti walls, to outdoor markets, to parking structures, to coffeehouses. I truly enjoy shooting in urban settings with seniors. Natural locations are well-suited to the more soft-spoken and outdoorsy personality types. Open fields, lonely roads, and sprawling hillsides all make beautiful settings.

Senior Portrait Products

I organize my senior portrait sessions into packages. Selling the senior package in advance of the session helps me to shoot with an awareness of what types of final products they will be receiving. Some of the products I offer in my senior packages are session books, graduation announcements, calling cards or rep cards, storyboards, image portfolios, wall prints, and smaller gift prints. Many of my clients are also interested in digital files, and I have chosen to offer these as part of my higher-end packages.

If I know that my client is interested in a session that includes graduation announcements and a session book, I make sure to capture some shots to use as background images in these print products. Alternatively, if the client has expressed interest in a large canvas print and has stated that they would like this to be a tight head-shot, I can compose my head-shots appropriately.

The Proofing and Sales Session

During the proofing and sales session with a senior client and their parents, you need to maintain balance between what the student wants and what their parents (who are paying the bill) want. Showing a good mix of more traditional and more creative portraits will ensure that everyone leaves the session happy. This session is handled much as the proofing sessions for other clients; a slide show begins the session, followed by guided selection of the favorites.

At the end of the session, I show the student a display shelf where I present the rewards they can earn as a student rep and give them an instruction sheet detailing the program. They receive their rep cards in a couple of weeks, and I usually see the first referral from that student within the month.

The final goal of the proofing and sales session is to select images to fulfill the products in their chosen collection and to finalize any additional orders.

The senior portrait proofing session will be a balancing act between the parents' tastes and the senior's preferences. Showing a mix of traditional and creative images will ensure everyone leaves happy.

9. Ongoing Relationship Marketing

Over the past chapters, I have discussed specific ways to market to different types of clients. Now I will go over general marketing campaigns that will keep you in the hearts and minds of *all* your clients—no matter what season of life they are in. These are simple ideas that can help you develop a marketing plan for your business. Make sure you are constantly promoting your business through repeated efforts that will call attention to your work and brand.

Web Presence, Blogging, and Social Networking

The Internet is an amazing and very affordable marketing tool. For starters, I recommend that every serious photographer have some kind of online presence. Most people look for photographers via Internet search engines or social networking sites; if you do not have an online presence, those people won't be able to find you or your work. If you are on a budget and cannot afford a custom-designed web site, begin with a free blog and/or Facebook business page. There are some great blogging services on the net—Blogger and Wordpress are two, but there are many more.

People like to make connections—to their friends, to their families, and to businesses they love. Social networking sites and blogging make this easy—and, often, *free.*

Facebook offers free business pages, which are some of the most powerful marketing tools you can employ. A Facebook business page allows customers to "like" your business (this was formerly referred to as becoming a "fan"). When people do this, Facebook will notify all of their friends that they "like" your business—and how awesome is that?

In addition to a business page, I recommend that you also create a personal account. The personal account on Facebook will allow you to become "friends" with your clients. Currently, Facebook only allows you to tag friends; so you will want your clients to be fans *and* friends so you can add a tag when you post their pictures. This will place those pictures on the client's own personal page and on the home pages of all of their friends. To encourage my clients and fans to tell their friends about my business page, I hold a giveaway every time my fan page gains another one hundred "likes" or "fans."

If you are going to use Facebook as a business tool, keep your personal page clean and appropriate for families. When posting personal pictures and comments, note that *all* of your "friends" see your activity; if you are constantly complaining, cursing, and otherwise acting badly on your personal page, you might alienate some

Kids are best contacted through their social networks, so sharing senior portraits images on Facebook and blogs will do wonders for your marketing efforts.

Social networking and blogging sites can help clients get to know you on a more personal level—and that is very good for relationship marketing.

of your clients. That is not to say that you cannot get personal, sharing your life and your feelings. Allowing your clients to get to know you more intimately is very good for relationship marketing. Commenting on your clients' pages in encouraging and positive ways can also help build your relationships with them.

Once you have a Facebook page and/or a blog, you can begin sharing your work—and hopefully begin drawing in new customers. Though a Facebook page and blog are great marketing tools, I do also recommend that you work to set up an official web site for your business as soon as possible. There are many wonderful web site services out there that cater to creative professionals and to photographers specifically.

I currently use Showit Sites for my company web site and could not be more pleased with its ease of use and the sheer power of this tool. It allows you to begin building your business web site quickly and easily with almost no web site design knowledge whatsoever. They even offer a free version that will allow you to build a small site, five pages max, and host it on their servers for free. Another amazing feature of Showit Sites is the ability to build "plus sites" (+Sites). These are sub-domains of your own web site and allow your

Using Showit Sites, you can allow your clients to have their own site for sharing photos. These make great add-on products for wedding packages, family portraits, and senior portrait sessions.

clients to have their own web site for sharing photos and information with family and friends. These "plus sites" are amazing product additions to wedding packages, and can make great add-on products for families and seniors as well.

Events for Families

One thing that families with small children love to do is attend events that are tailored to them. Whether you have a studio space or not, you can hold special events for your clients that will encourage and reward them.

During holiday seasons, you can hold special-event portrait days, offering families an opportunity to have portraits taken with Santa Claus, or in their Halloween costumes, with spring chicks and bunnies, or at the beach. Every season offers unique possibilities.

Mini-session events can present families with the opportunity to have smaller sessions with you, and give new clients a chance to check out your services and work in a very affordable way. During these events, clients are given the opportunity to book a twenty- to thirty-minute session on a date that you determine and at a discounted rate. I limit the number of proofs I present from the mini-sessions to twenty—just to keep things simple. Typically, I offer mini-sessions every couple of months, advertising the events on my blog, Facebook page, Twitter, and via an e-mail newsletter blast. To streamline the process, you may want to offer a few different package options for purchase with your mini-sessions. I like to offer a digital file package, including ten to twelve digital files on a disk, as well as a couple of print packages.

Keeping up with local community events tailored to families is also a great way to reach new customers and get your name out into the community. Consider purchasing booth space at the next Kids Fair or Family Fun Day in your community, then offer prepaid sessions at a discount to the families that attend. Another great way to reach potential clients is to contact local schools and offer to cover their fundraising events. Carry your business cards with you and hand them to families as you photograph candid shots, offering to provide a free 4x6 print

Portrait parties let you meet and photograph lots of people in a short amount of time—a great, low-cost way to introduce people to your business.

of the photo you just shot. All of these options will help generate brand recognition in your community.

Portrait Parties

Portrait parties can get people talking about you and your studio, generating those valuable word-of-mouth referrals. The parties can be held at a local park, in your studio, or at a client's home. Schedule two dates: the first for the sessions, and the second (two to three weeks later) for the "preview party." Party hostesses can then contact their friends with kids and schedule them into twenty- or thirty-minute time slots on the session date. At the pre-

view party (preferably for parents only), you can present a slide show of all the proofs, then sit down individually with each parent and take their order—or offer online proofing for placing orders. I offer special packages that are available on that night only, encouraging sales at the preview party.

Annual Promotions

The best way to plan ahead for your marketing efforts is to create an annual marketing outline. Putting all of your intended marketing plans down on paper and constantly referring back to it will help guide your business in the direction that you intend. I recommend sitting down once a year and putting your seasonal marketing efforts onto a calendar that you can use as a guide through the year. Plan ahead for different seasons in a way that will allow enough time for you to put these plans into action. Creating annual and seasonal promotions that your clients can begin to count on will establish a consistency in your business and help you to stay on top of upcoming events.

Giving Back

As business owners, I feel we have an opportunity and responsibility to give back to the communities that support us. If families are the cornerstone of society, as I believe, then communities are really just big extended families. Photographers have unique talents and abilities that can be valuable to charitable organizations. Our ability to capture life, emotion, and connections can be a blessing to non-profit organizations and to individuals.

There are a number of wonderful and highly reputable organizations that use the specific talents and great generosity of photographers on a local and global scale to make a difference for the better. You can begin giving back today by contacting a local charity and offering your services in any way they can use you.

Giving of yourself, you will find, is one of the most energizing and spiritually fulfilling practices you can undertake. The profound sense of connectedness and humility you will experience will fuel your work in a way not possible when your talents are only offered to those who can pay you. Consider it your privilege to have been given your unique talents, and your duty to share those talents to affect real change in your world.

Some of the many organizations that offer unique opportunities for photographers to give back are:

Help-Portrait (www.help-portrait.com). Find someone in need, take their portrait, then give it to them.

Now I Lay Me Down To Sleep (www.nowilaymedowntosleep.org). This organization provides free professional portraiture to families suffering the loss of a baby.

Thirst Relief (www.thirstrelief.org). Thirst Relief provides safe, clean drinking water to people around the world.

RIGHT AND FACING PAGE—Creating an annual marketing plan will allow you to make the most of each session type you offer. Scheduling annual and seasonal promotions that clients can count on will also help you to build repeat business.

While the purpose of giving back should be 100 percent altruistic, there will be some innate benefits to your business when you establish a habit of giving back.

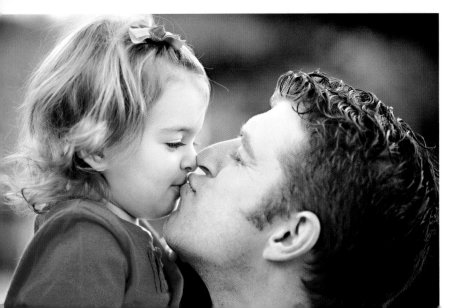

Pictures of Hope (www.picturesofhope-foundation.org). This group provides complimentary photography services to the families of infants in neonatal intensive care.

Celebrating Adoption (www.celebrating-adoption.org). Celebrating Adoption offers photography sessions to families in the process of adoption.

Operation Love Reunited (www.oplove.org). This organization supports our troops with photography sessions of their families.

There are many worthy causes out there—all you really need to do is get out there and make yourself available. For example, you could offer photography sessions to families living in transition through local group shelters. Many cities have organizations that support women with children who are attempting to leave abusive situations. Capturing these families in portraiture that celebrates their freedom from violence, as well as their bond and connection, can be tremendously meaningful. You can also donate to silent auctions and charity events. Just make your services known to these organizations and they will gladly let you know how you can help.

While the purpose of giving back should be 100 percent altruistic, there will be some innate benefits to your business when you establish a habit of giving back. Besides the invigoration and new vision your work will inevitably take on through the selfless act of giving, you will also notice that the people who are involved with these organizations will appreciate your effort and remember you when they (or people they know) are in need of photographic services. Giving back is good for business and good for businesspeople. It should be a part of every healthy business.

Where to Go From Here

This adventure will take work, long hours, and much dedication—but I promise you, it's worth it.

I hope that the information presented here has been beneficial and inspiring to you—and that you will return to this guide frequently as you put the information into practice in your business.

Constant learning and growth are vital to realizing success in our industry, because the technologies we employ in both our art and our business administration practices are constantly advancing. Please consider it a necessary part of your business to join such professional organizations as the PPA (Professional Photographers of America), WPPI (Wedding and Portrait Photographers International), and others. These organizations serve to support their members with opportunities to grow and learn and are invaluable to all professional portrait photographers.

My advice to you is take any changes in your business, as well as the initial inception of your business, one step at a time. Growth takes time and patience. When I filled out the application papers for my very first annual business license nine years ago, I was filled with excitement and hope. I felt that simply by stating that I was "in business" I would suddenly have a successful business. This is not the case, as I learned over the years that followed. Business ownership is not simply the act of offering one's services for a fee. This adventure will take work, long hours, and much dedication—but I promise you, it's worth it.

I am overjoyed to have been able to offer you my knowledge and experience through this book, and thank you for taking the time to read and hopefully gain insight from my experiences. I have also made myself available through my web site and blog (www.jlmcreative.com) as well as via Facebook (facebook.com/jlm creative) and Twitter (@christiemumm). Please stop by, friend me, and say hello. I would be delighted to hear from you—so tell me about your business and your life! If this book has been of help to you, I would love to hear about it and to provide any additional guidance and advice I can to those who share my passion for photography and my love of families.

If you put your heart and soul into your work, invest yourself in the lives of your clients, and stay true to who you are, I am confident that you will be successful.

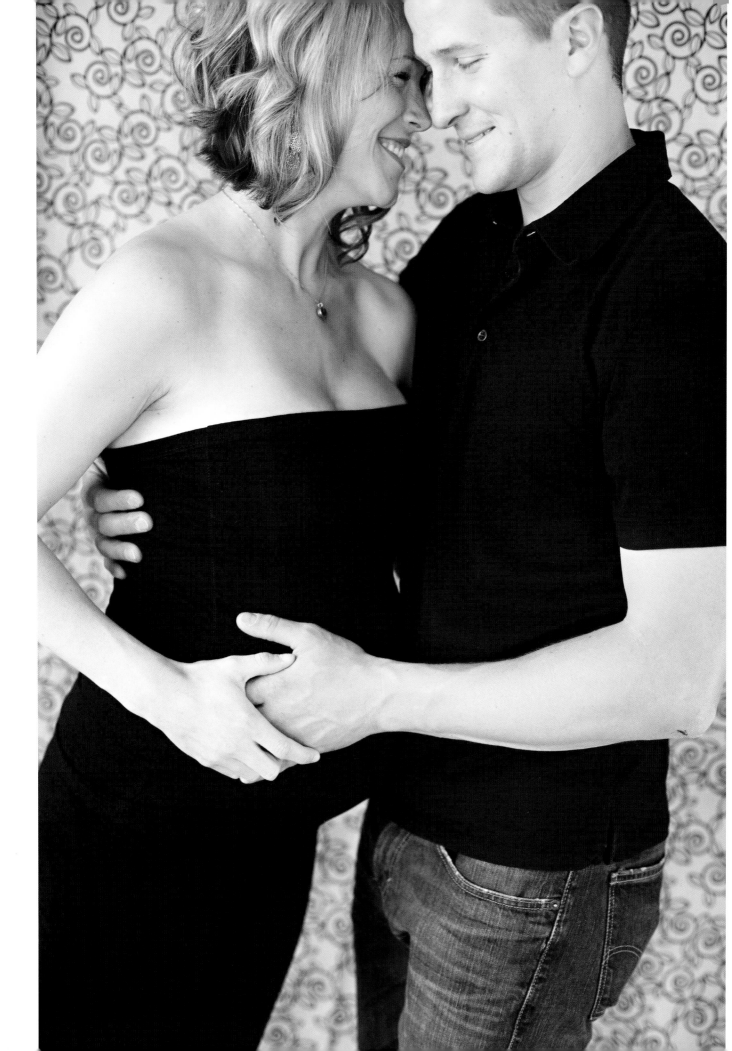

Vendors

Design Templates

Life Art Design Shoppe (Rock the Walls Templates)—
www.lifeartdesign.com

Royalty-Free Music

Triple Scoop Music—www.triplescoopmusic.com

Broken Joey Records—www.brokenjoeyrecords.com

Actions

Kevin Kubota's Artistic Actions III—www.kubota
imagetools.com

Totally Rad Actions Sets I & II—www.gettotallyrad.com

Software

TimeExposure ProSelect—www.timeexposure.com

Adobe Photoshop and Photoshop Lightroom—
www.adobe.com

LumaPix FotoFusion—www.lumapix.com

Photodex ProShow Producer—www.photodex.com

Datacolor (Spyder)—www.datacolor.com

Photo Price (app)—www.photopriceapp.com

Blogs, Websites, etc.

Wordpress Blogs—www.wordpress.com

Blogger—www.blogger.com

Showit Sites—www.showitfast.com

Facebook—www.facebook.com

FACING PAGE—Constant learning and growth are vital to realizing success in our industry, because the various technologies we employ in our art and our business administration practices are constantly advancing.

Photographic Props and Backgrounds

Photo Prop Floors and Backdrops—www.photo
propfloorsandbackdrops.wordpress.com

Etsy—www.etsy.com

Craigslist—www.craigslist.org

Ebay—www.ebay.com

Product Vendors and Labs

White House Custom Color—www.whcc.com

Full Color—www.fullcolor.com

Millers Professional Lab—www.millerslab.com

Black River Imaging—www.blackriverimaging.com

Canvas On Demand—www.canvasondemand.com

Finao Albums—www.finaoonline.com

Professional Organizations

Professional Photographers of America—www.ppa.com

Wedding and Portrait Photographers International—
www.wppionline.com

Forums and Blogs

Open Source Photo—www.opensourcephoto.net/forum

Clickin' Moms—www.clickinmoms.com

The [b] School—www.thebschool.com

I Love Photography—www.ilovephotography.com

Digital Photography Review—www.dpreview.com

Strobist—www.strobist.com

Rock That OCF—www.rockthatocf.com

Automated Card and Gift Sending

Send Out Cards—www.sendoutcards.com/
christiemumm

Index